IMAGES
of America

ATHOL
MASSACHUSETTS

On the Cover: Time has obscured the certainty of identification of the individuals in this photograph taken in front of the Academy of Music Building on Exchange Street.

IMAGES
of America

ATHOL
MASSACHUSETTS

Robert Tuholski, Ph.D.

ARCADIA

Published by Arcadia Publishing,
an imprint of Tempus Publishing, Inc.
2 Cumberland Street
Charleston, SC 29401

Printed in Great Britain.

Library of Congress Catalog Card Number: Applied for.

For all general information contact Arcadia Publishing at:
Telephone 843-853-2070
Fax 843-853-0044
E-Mail arcadia@charleston.net

For customer service and orders:
Toll-Free 1-888-313-BOOK

Visit us on the internet at http://www.arcadiaimages.com

ACKNOWLEDGMENTS

The author would like to express special thanks to Rosamond E. Malatesta, M.Ed., of the Tewksbury, Massachusetts Public Schools, for her encouragement, suggestions, and invaluable editorial assistance. Thanks are also extended to all those who added facts, figures, and recollections to supplement the images shown herein. Without their help the book would not have been possible.

ABOUT THE BOOK

Rather than a definitive history of the Town of Athol, this work is a photographic examination of Athol in the years surrounding the turn of the twentieth century. It is not all-inclusive; a work of that nature would certainly be capable of filling several volumes, since collections of photographs of Athol are numerous and voluminous. Selected images are used to provide a broad view of life in Athol at the dawn of the twentieth century.

The images used are solely from the collection of the author, with no additions. They have been amassed over nearly 25 years of purchasing at flea markets, antique shops, and antique shows throughout the Northeast and beyond. When known, the originator of each image is shown in parentheses after the caption.

CONTENTS

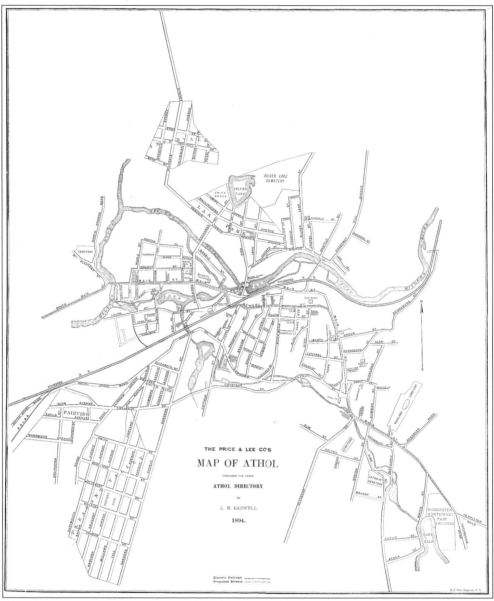

The 1894 map of Athol by L.B. Caswell, which appeared in Price & Lee Company *Athol Directory 1894*, shows streets, rivers, streams, and bodies of water referred to in this book.

INTRODUCTION

The first settlers came to Paquoig (one of several spellings) in 1735. With their families, Richard Morton, Samuel Morton, Ephraim Smith, John Smeed, and Joseph Lord chose Paquoig as the location where they would settle into an agrarian lifestyle. At mid-century, the advantages of incorporation as a town were recognized. John Murray, a major landowner in Paquoig, suggested that the area reminded him of his birthplace in Blair Atholl, Scotland. When the charter of incorporation was drawn up in 1762, the name Athol appeared thereon.

From agrarian beginnings, Athol grew into a manufacturing center because of the ideal geological combination of abundant water and a considerable drop in elevation through which the water flowed. As the Industrial Revolution gripped the nation during the 1800s, Athol became attractive to manufacturers seeking water as a source of power for their mills.

Mill Brook

Nearly forgotten today, this stream was the source of power for no fewer than nine of Athol's early manufacturing concerns. It flowed downward from Lake Ellis to the Millers River near South Street. After passing under Lake Ellis Road (then Water Street) Mill Brook first served the Edwin Ellis & Son Sash & Blind factory near Gibson Drive. From here, a considerable body of water called Morse's Pond was formed by the L. Morse & Sons furniture factory on Mechanic Street. Morse Pond extended from close to Lake Ellis Road to Vine Street.

Continuing from Morse's Pond, Mill Brook flowed west beneath Spring Street at Estabrook Street, to the corner of Pleasant and Main Streets, where Brewer's Box Factory realized its potential. It then flowed under Pleasant Street, between Fire Station No. 2 and Main Street, to the Hill & Greene shoe factory where F.L. Castine, Inc. is now located. From here, it dropped into a pool called Match Pond that served the Edson Fitch Match Block Factory east of the intersection of Hapgood and Chestnut Streets. After the Fitch Factory, it flowed to the Athol Pump Company in the triangle formed by Riverbend, Fletcher, and Hapgood Streets.

Next to take advantage of Mill Brook was the Goddard & Manning Piano Factory at the northeast corner of the Cottage and Chestnut Street intersection. At this point, it split into two channels. One channel flowed under Cottage Street and into a large pool that existed in the rectangle formed by Chestnut, Cottage, Hapgood, and Sanders Streets. The second channel flowed north, parallel to Cottage Street to the Millers River Company where Boston Filter

Company is now located. From here, it flowed west into the same pool as the first channel.

At the Hapgood Street end of the large pool, Mill Brook served the J. Wesley Goodman & Sons Billiard and Pool Table Factory. The Brook then flowed under the intersection of Hapgood, Sanders, and Tunnel Streets. It then passed beneath the railroad tracks, Carbon Street, South Street and emptied into a large pond formed by a branch of the Millers River that filled the area in what is now Lord Pond Plaza.

Millers River

The Millers River was first utilized by the W.H. Amsden door and sash factory at the northeast end of Kennebunk Street. It was then dammed for use by the Millers River Manufacturing Company just east of the Chestnut Hill Avenue Bridge. It also served the factory of Gay & Ward (Union Twist Drill Company) west of the Bridge before being restricted by the L.S. Starrett Company dam at Crescent Street.

Immediately west of the L.S. Starrett Company, a channel from the Millers River passed nearly to Main Street where the Athol Public Library and Memorial Building now stand. At this point, the channel split in two. One branch flowed under a bridge on Island Street and roughly paralleled Marble Street as it flowed west. This branch then flowed beneath Exchange Street north of where Tool Town Pizza/Rise & Shine Donuts are now located. From here it curved gently northward and rejoined the Millers north of the sharp bend of Shore Drive.

The second branch of the channel that was formed at the site of the Library and Memorial Building flowed southward under Main Street at the west end of the present YMCA building. It then formed a pool in what is now the public parking lot behind the Main Street blocks. This pool drained beneath Exchange Street south of the present Athol-Clinton Cooperative Bank where it was met by Mill Brook next to the present Niagara Cutter factory. Here a large pond was formed by a dam at Freedom Street where Victory Super Market now stands. Nearly the entire area of the Lord Pond Plaza parking area was filled by this pond.

After leaving the dam at Freedom Street, water from this second branch passed the Sawyer Tool Company on the west side of Freedom Street to the D.E. Adams and Company Silk Mill that fronted on Lumber Street. From here it passed under Canal Street where it split into several channels, one of which served the Athol Machine Company at the west end of South Street. It then rejoined the Millers River.

Much of the infrastructure associated with the harnessing of water for power in Athol still exists; though some has been removed. Water that flowed above ground in some locations has been diverted to underground culverts. Each time we drive along Main Street near the YMCA or park behind the businesses on Main Street or at Lord Pond Plaza we are, without even realizing it, "visiting" a part of Athol's rich industrial past. The water that was so vital to the industrial community of Athol is still there. Like so much of history, it is now hidden from view. Though we hardly notice it any longer, Mill Brook is still there. Most of the factories are gone, but their legacy in the form of canals and dams are still visible. The dam near the intersection of Hapgood and Chestnut Streets still stands, though the years have taken their toll on it. A glance at it today yields an immediate sense of insignificance. This may be true today, but at the turn of the century, the seemingly insignificant dam and others like it were critical to the development of Athol into a vital, thriving industrial community.

One
MAIN STREET

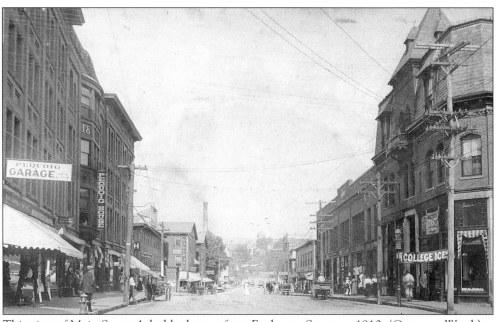

This view of Main Street Athol looks east from Exchange Street, *c.* 1910. (Converse Ward.)

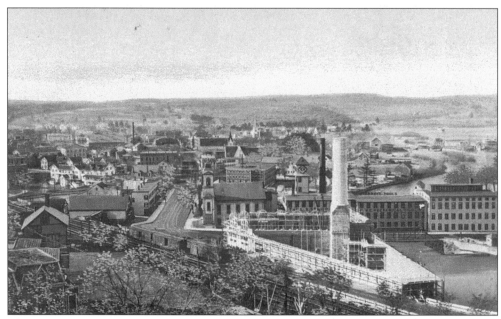

This bird's-eye view of Athol from School Street is looking west along Main Street. It shows the power plant of the L.S. Starrett Company under construction, dating the image to 1908 when the plant was erected. (Longley & Longley.)

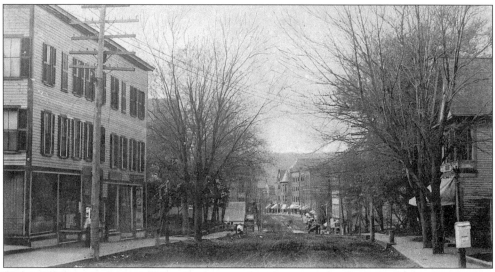

This c. 1905 postcard view of Main Street was taken from near the Crescent Street intersection. Clearly missing at the right is Memorial Hall and the Athol Public Library. In the distance are the Pequoig Block and the Millers River National Bank at the intersection of Exchange Street. (C.E. Ingalls.)

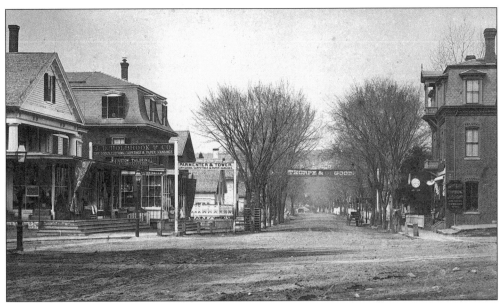

Stately elm trees lined Main Street looking west from Exchange Street *c*. 1880. In the distance is a covered bridge that spanned Millers River where the South Main Street Bridge now stands. (Lithotype.)

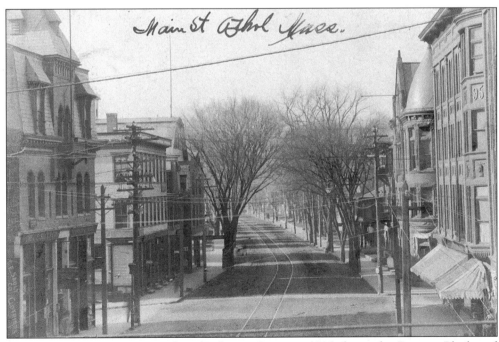

Looking west on Main Street from Exchange Street *c*. 1905 shows the Pequoig Block and Millers River Bank Building on the right. The trolley tracks were laid in 1894.

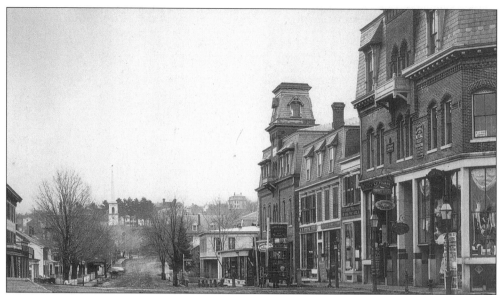

Not much is familiar to us today in this image of Main Street looking east from Exchange Street, c. 1880. The Starr, Central, and Masonic Blocks appear on the right. The Central and Masonic Blocks were destroyed by fire in 1890 and replaced with the Webb Block. The steeple in the background is that of the Methodist Church that stood at the corner of Main and Crescent Streets. (Lithotype.)

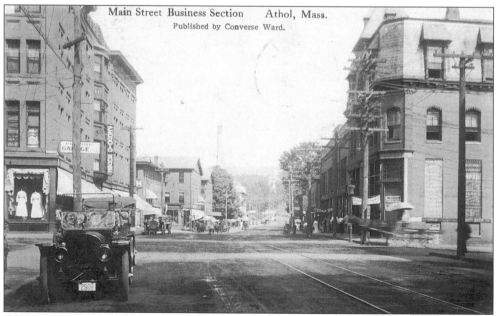

By 1911, Main Street looking east had taken on a more familiar appearance. The Pequoig Block on the left and the Starr and Webb blocks on the right dominate the intersection of Main and Exchange Streets. (Converse Ward.)

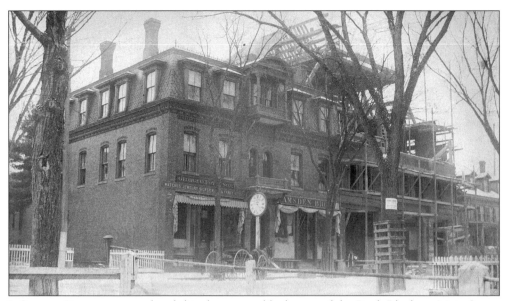

J. Sumner Parmenter completed this three-story block west of the Bank Block on Main Street in 1872. The Millers River National Bank purchased it just before construction of its new Bank Block, shown here being built *c.* 1888. The western ell of the Pequoig Hotel appears at the far right.

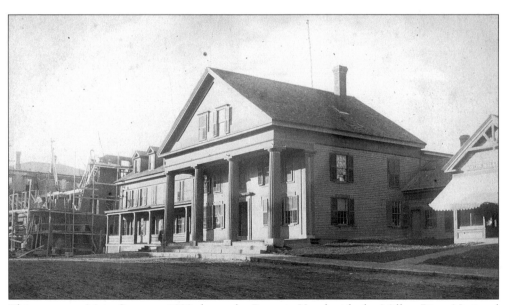

This scene on Main Street *c.* 1888 shows the Pequoig Hotel with the Millers River National Bank Block under construction.

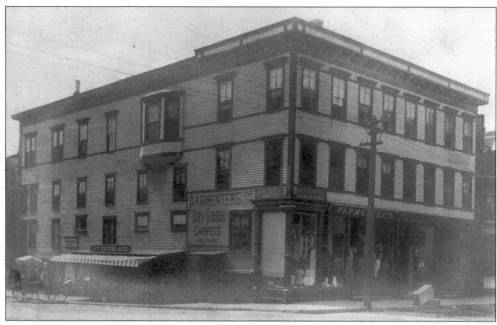

At the southwest corner of the intersection of Main and Exchange Streets stood the Parmenter Block. It was on the current site of the proposed Veterans Memorial Park. In its later years, the building housed a barbershop in the basement below the large "Dry Goods-Carpets" sign. A bridal boutique was located in the upper level where the "Parmenter's" sign appears.

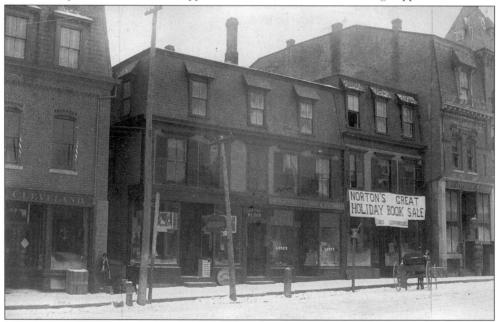

Located on Main Street at the current site of the Webb Block, the Central Block and the Masonic Block, partially visible at the left, were destroyed by fire in 1890. Four firefighters from Athol and two from Orange were seriously injured fighting the fire. One, Alexander McLeod, succumbed to his injuries. He was the first Athol firefighter to lose his life carrying out his duties.

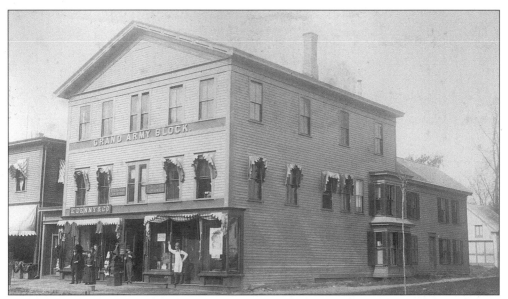

About 1885, George H. Cooke purchased the Knowlton homestead and built this three-story block at 464–468 Main Street. The Grand Army of the Republic (GAR) soon became his third-floor tenant, and he named the building the Grand Army Block. Today the ground floor is occupied by Floors & More.

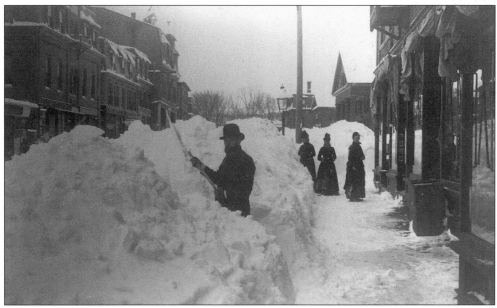

Snow, snow, everywhere there was snow after the famous "Blizzard of '88," March 12, 1888. Main Street in Athol was no exception. Shown here clearing snow from in front of his dry goods store in the Grand Army Block is Mr. Denny. Looking on are Alma Whitney, Abbie Sherwin, and Mrs. A Towne. The building with the columns, visible above the very fashionably dressed women, is the Pequoig Hotel.

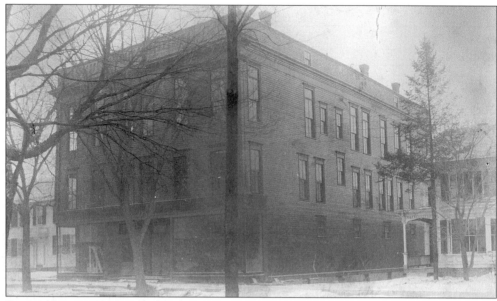

Pictured here *c.* 1890 is the block at 505 Main Street. At one time, the unit to the left was occupied by the long forgotten Gem Movie Theater. The building was extensively damaged by fire in 1916, after which it was purchased by George H. Cooke and rebuilt. Flowerland now occupies the ground floor.

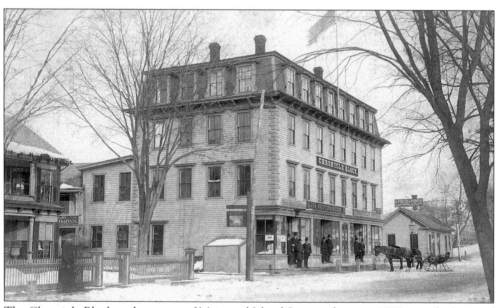

The Chronicle Block at the corner of Main and Island Streets, shown *c.* 1890, was the home of the *Worcester West Chronicle*, one of two weekly newspapers serving Athol. The other was the *Athol Transcript*. The small building at the right is the barbershop of Cornelius Leonard Jr. Notice the barber pole on the Main Street side of the barbershop. Island Street passes between the Chronicle Block and the barbershop.

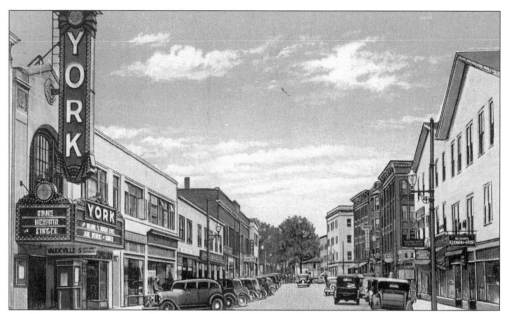

By the 1930s, Main Street looking west had taken on the appearance familiar to us today. At left is the York Theater, which was the premier movie theater of the day. It is now Lucky Lanes Bowling Alley. Notice that parallel parking and parking meters were not the order of the day. (C.W. Hughes.)

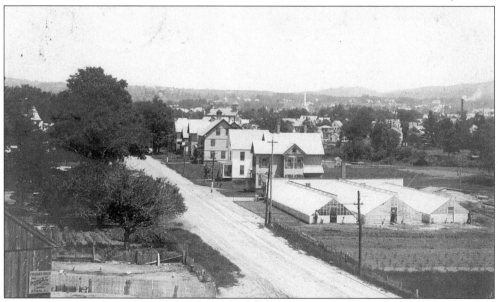

The Sutherland Greenhouses next to the 192 South Main Street home of George W. Sutherland are the focus of this c. 1905 view. The image looks toward the center of Athol.

Main Street looking north near Central Street is shown in this *c.* 1880 photograph. The First Unitarian Church / Town Hall, now the Athol Historical Society, is visible through the trees at the left. (Lithotype.)

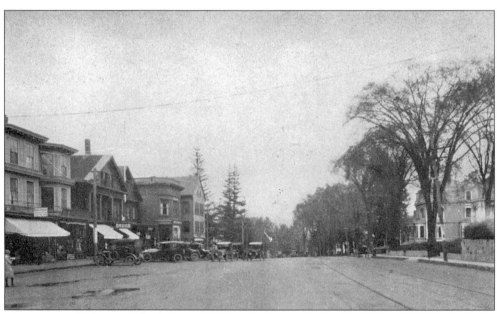

Main Street looking north from Grove Street is shown in this *c.* 1925 postcard image. (A.M. Simon.)

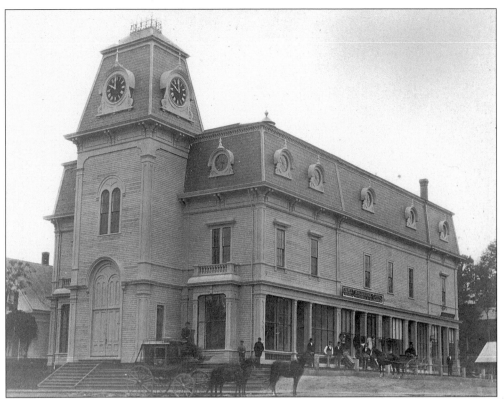

The Music Hall at the corner of Main and Grove Streets served as a meeting place for a very short four years. Dedicated in 1872, the building burned to the ground in 1876. The storefronts to the right faced Grove Street, while the main hall entrance fronted on Main Street.

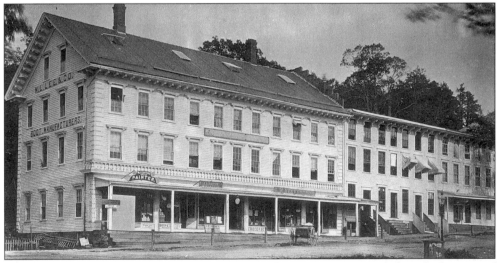

The Union Block at 1576–1588 Main Street served many purposes, including the housing of several small businesses at street level. The Merit L. Lee Boot Shop occupied the top two floors when this c. 1880 photograph was taken. It later served as Grange Hall. The building was razed in the late 1930s to make room for a gas station. Huhtala Texaco stands here today. (Lithotype.)

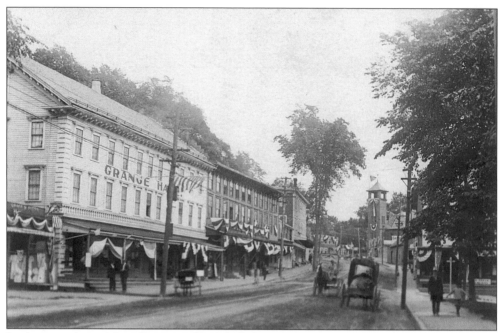

Looking south on Main Street at the Athol Center Common *c.* 1912 reveals Grange Hall (Union Block) with Athol Fire Station No. 2 at the corner of Pleasant Street in the distance.

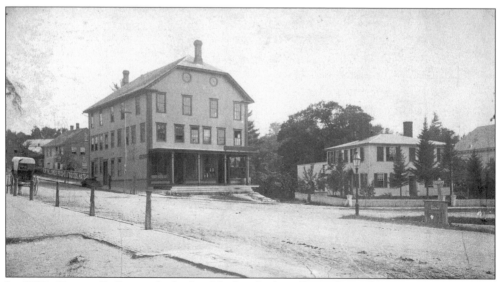

In 1883, George S. Brewer built this block, which still stands at the corner of Main and Chestnut Streets. Beginning in 1883, the Athol Lodge of Freemasons met in the upper levels of the building for more than 30 years. For many years, Charles B. Bemis operated a bakery and lunch counter on the ground floor. Also shown in this *c.* 1885 photograph is the M.L. Brewer house, which burned in the 1960s.

Two

Public Buildings, Schools, Churches, and Banks

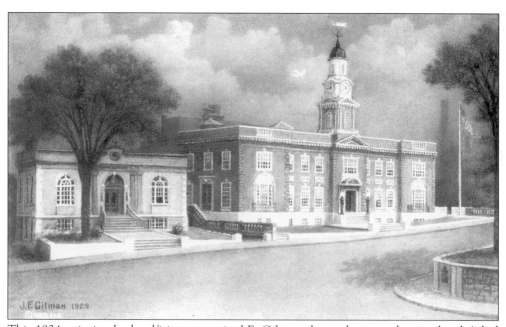

This 1924 painting by local/itinerant artist J.F. Gilman shows the recently completed Athol Memorial Building at the right, and the Athol Public Library at the left. The Library opened at this Main Street location in 1918.

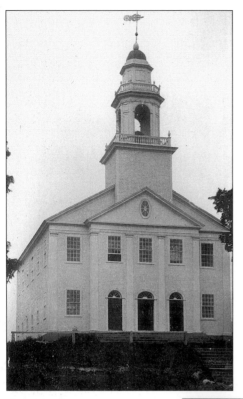

The town hall and First Unitarian Church were originally built in 1828 as the church. In 1847 it was completely renovated and enlarged with the upper level becoming the town hall and the lower level the church. It served as the official meeting place of Athol for about 75 years. It now belongs to the Athol Historical Society. (Lithotype.)

Shown here c. 1930 is the Athol Memorial Building at 584 Main Street. It was built on land donated by Laroy S. Starrett. The cornerstone was laid in 1922, and the building was completed in 1924. The smokestack at the right is at the L.S. Starrett Company power plant at the corner of Main and Crescent Streets.

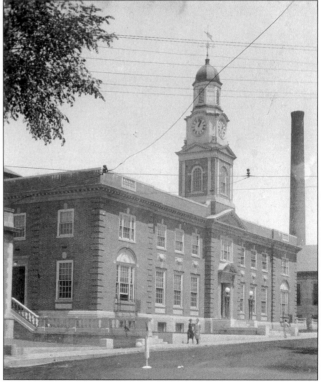

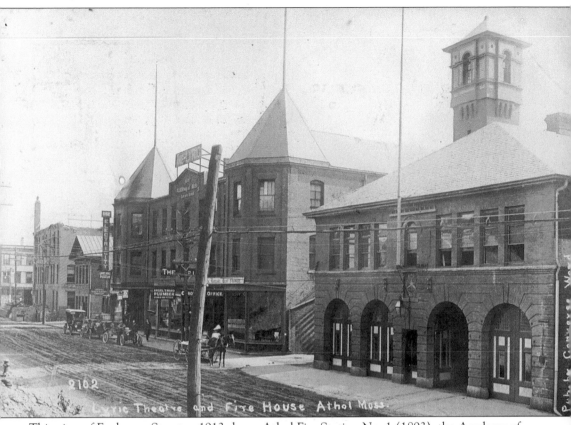

This view of Exchange Street *c.* 1913 shows Athol Fire Station No. 1 (1893); the Academy of Music Building (1892), which is now the parking lot for the Athol Savings Bank; and the Millers River National Bank building at the corner of Main and Exchange Streets. Construction on the top of the Bank building was to repair fire damage that seriously burned the roof in 1913. (Converse Ward.)

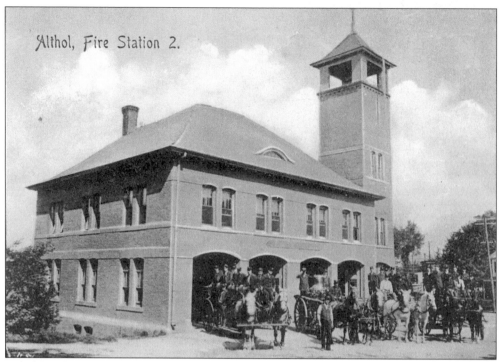

Athol Fire Station No. 2 was built at the corner of Main and Pleasant Streets in 1896 at a cost of about $12,000.

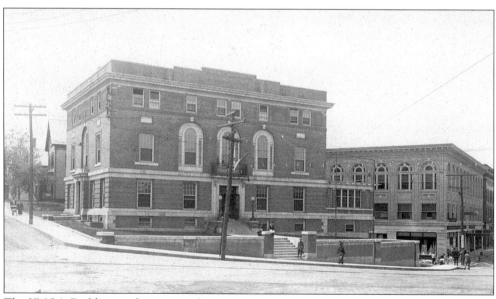

The YMCA Building at the corner of Main and Traverse Streets was dedicated on March 15, 1912. The land was donated by Laroy S. Starrett, who built the Starrett Building on the right in 1915. (Underwood & Underwood.)

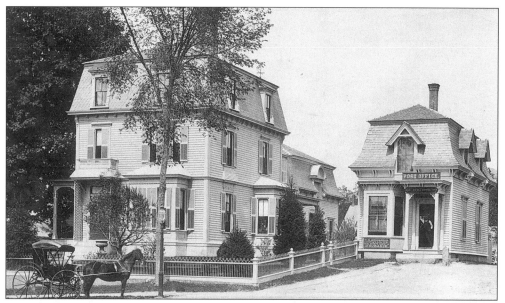

The Athol Center Post Office was located beside the 1450 Main Street residence of Postmaster Thomas H. Goodspeed. Goodspeed was postmaster from 1862 until 1885. (Lithotype.)

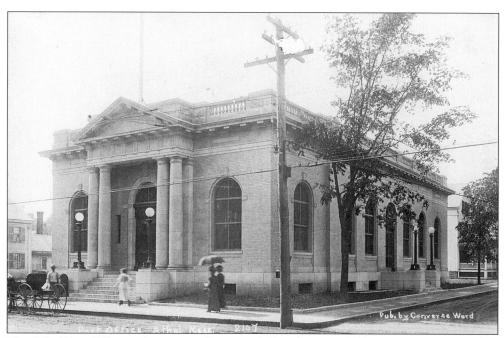

The Athol Post Office at the corner of Main and Church Streets is shown here shortly after its opening in 1913. It is now the Athol Masonic Temple. (Converse Ward.)

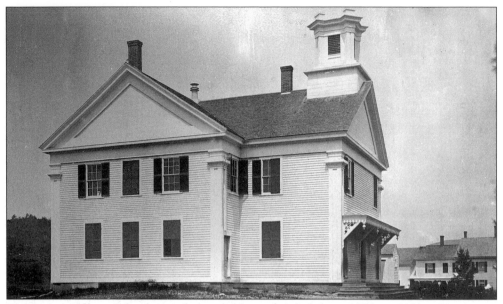

The Lower Village School served the children of Athol from 1870 to 1889, when it was replaced by the familiar Main Street School. (Lithotype.)

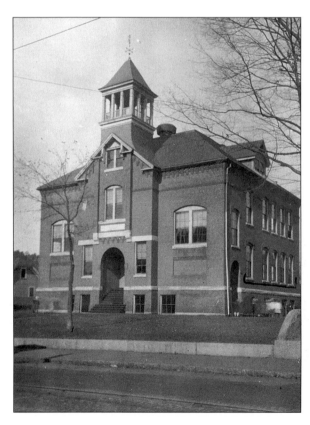

Main Street School at 100 Main Street was built in 1889. Today it is the Human Resource Center.

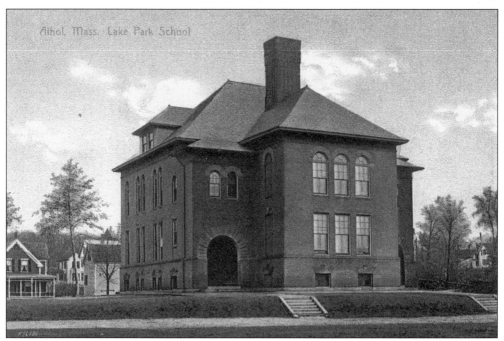

Built in 1894, Lake Park School was at the intersection of Fish Street and Pequoig Avenue. It is now the site of a playground for children. (Longley & Longley.)

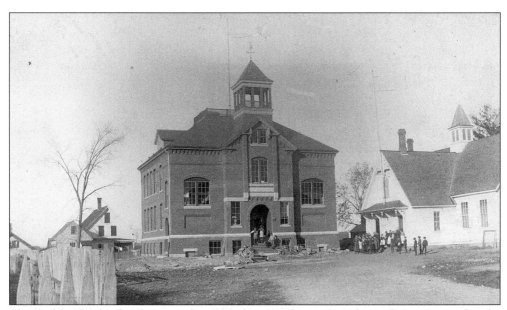

The Highland School is shown in this 1890 photograph as it neared completion. Located at the end of Auburn Place, it opened in 1891 and was a very close copy of the Main Street School.

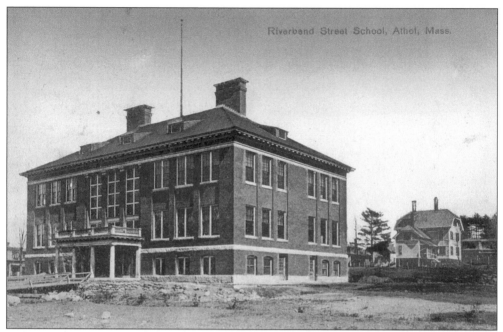

The Riverbend Street School was built at the turn of the century to alleviate overcrowding at the high school. It stands at the intersection of Riverbend and Allen Streets. It served as a junior high school until 1958 when the Athol-Royalston Regional High School opened, and the old high school on School Street became the Athol Junior High School. (Greene & Sawyer.)

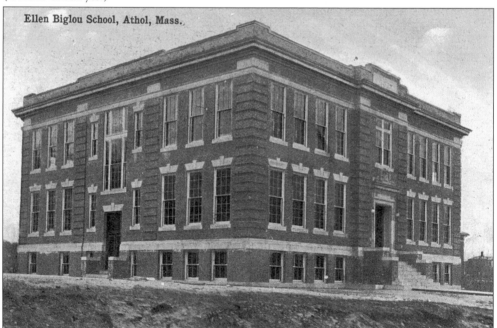

The Ellen Bigelow School was built in 1911 on the same site as the Riverbend Street School. It was named after Ellen M. Bigelow, a highly regarded Athol schoolteacher of more than 50 years. Note the incorrect spelling of her name on this postcard image.

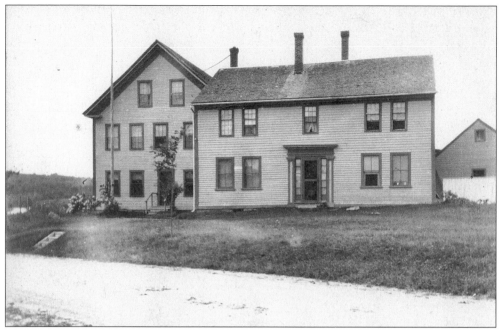

This *c.* 1908 photograph shows the District Number Six Schoolhouse at the left. It was referred to as the "Poor Farm School House" by a then unenlightened public because of its location at the rear of the Welfare House for the indigent, also shown in this photograph. The school was moved and altered to become a carriage barn and shop for the Welfare House. The site is on Templeton Road nearly opposite Orchard Street.

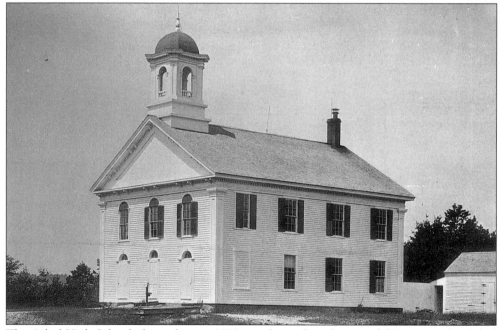

The Athol High School, shown here *c.* 1880, was located on the site of the present-day Athol Middle School. It served from 1857 to 1892, when it was replaced with a new brick schoolhouse at the same site. (Lithotype.)

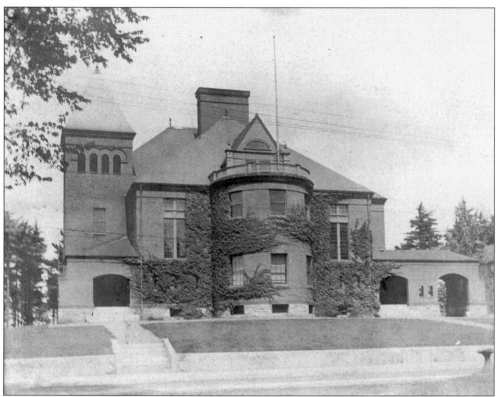

Replacing the original Athol High School in 1892, this brick building has been reconstructed over the years and is now the Athol Middle School. It originally cost the Athol taxpayers about $25,000.

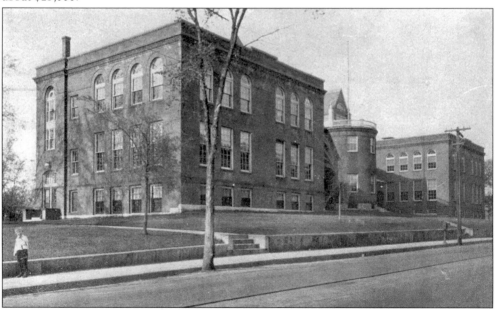

As the population of Athol grew, so did the high school. Readily distinguishable between the wings added in 1915 is the edifice of the 1892 building. (Simon.)

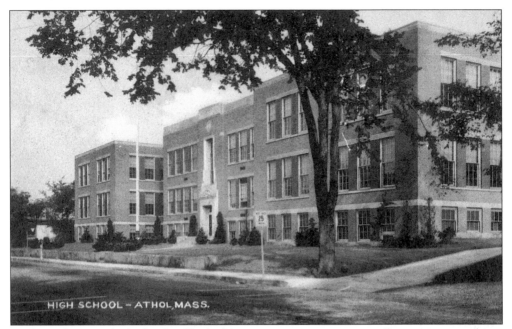

By the mid-1940s, the high school had taken on its present appearance. Gone was any evidence of the original structure. It served as the high school until 1958 when the Athol-Royalston Regional High School opened. It then became the Athol Junior High School, and is today the Athol Middle School.

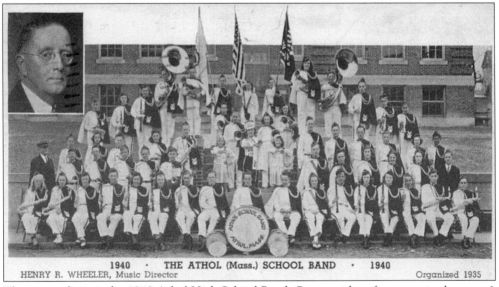

1940 · THE ATHOL (Mass.) SCHOOL BAND · 1940
HENRY R. WHEELER, Music Director Organized 1935

The image above is the 1940 Athol High School Band. Can you identify anyone in the group?

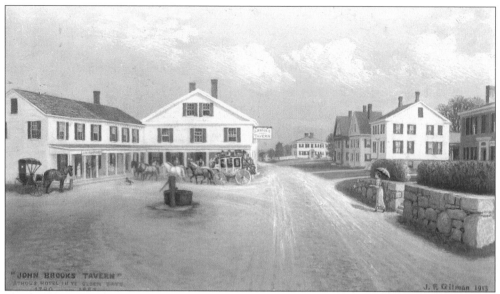

Brooks Tavern, which stood at the approximate location of the Summit House next to the Athol Center Common until 1853, is shown here in a painting by artist J.F. Gilman. The painting, done in 1913, looks north on Main Street from the Common. Grove Street is to the right at the stone wall.

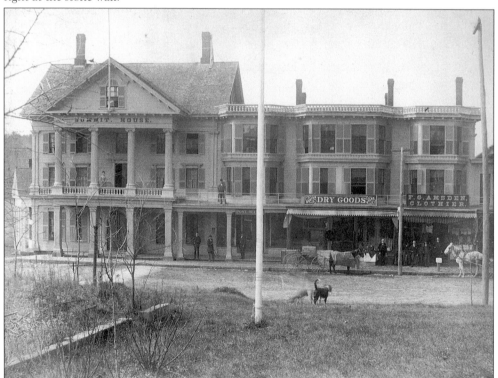

Opened in 1858, the Summit House offered the latest in hotel accommodations. It stood at the corner of Main and Common Streets until it was replaced in 1929 with the Summit Block. This is where Larry's Variety, Athol Savings Bank, and Bruce's Pharmacy are presently located.

32

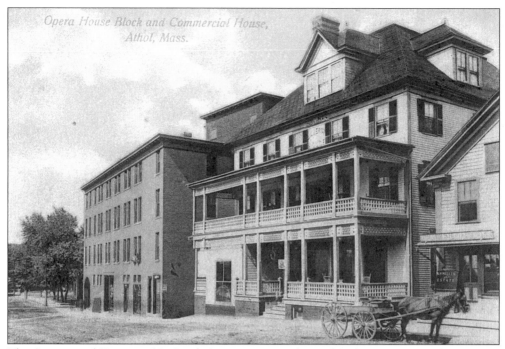

The Commercial House at 550 South Street, opposite the Railroad Station, opened in 1891 as the outstanding inn of the time. To the left is the Opera House Block at the corner of Exchange Street. The Commercial House was taken over by the Leonard family in 1903, and was seriously damaged by fire in 1916. (W.B. Hale.)

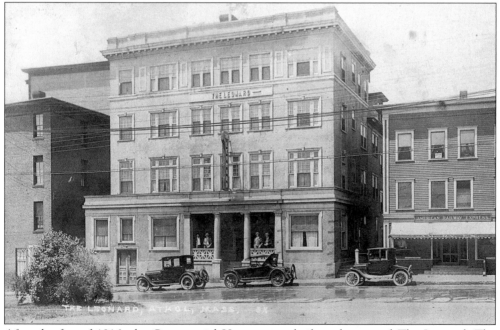

After the fire of 1916, the Commercial House was rebuilt and renamed The Leonard. The building was used as a hotel and eventually as a rooming house until it was demolished to make room for the present parking garage. It is shown here *c.* 1925. (Eastern Illustrating.)

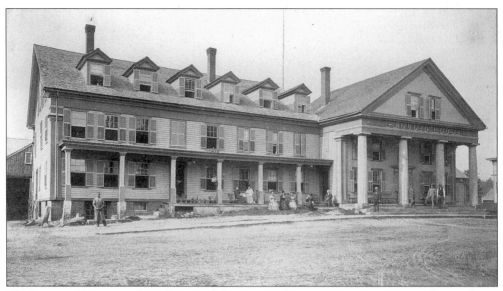

The Pequoig House stood on the site of the present-day Pequoig Apartments at the northeast corner of Main and Exchange Streets. The stable, visible to the left, and most of the ell is the approximate location of present-day Exchange Street. This building, which served for many years as Athol's business district hotel, was demolished and replaced with the Pequoig Block in 1895. (Lithotype.)

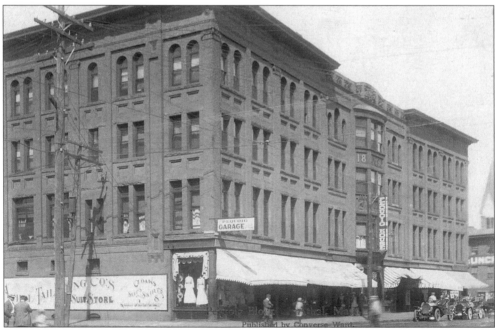

When completed in 1895, the Pequoig Block housed local businesses on the ground floor and a modern hotel known as the Pequoig House on the upper floors. It is now a facility for elders, with the Athol Senior Center and Paradise Jewelers on the ground floor and apartments for the elderly on the upper floors. (Converse Ward.)

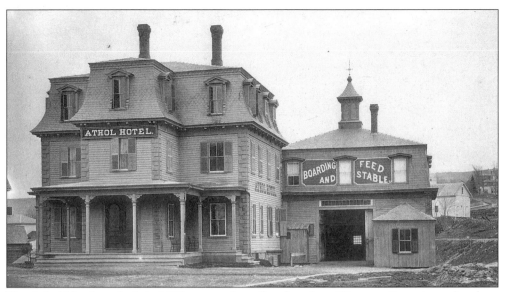

The Athol Hotel was built in 1873 next to the railroad tracks on Traverse Street just a few short steps from the railroad station. It was extensively damaged by fire in 1894. (Lithotype.)

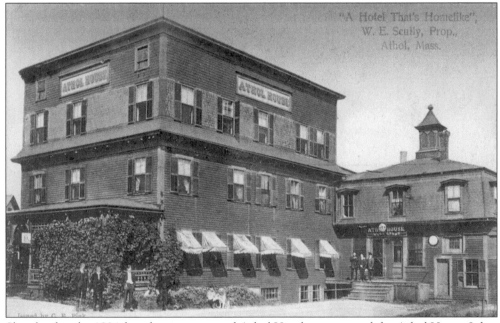

Shortly after the 1894 fire, the reconstructed Athol Hotel was renamed the Athol House. It has since served several purposes in addition to being a hotel, including offices and a restaurant. A nightclub was once located in the small building, originally the stable, at the right. Brothers Pizza is now located here. (Green & Sawyer.)

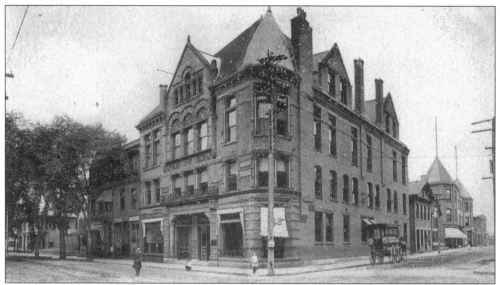

The Bank Block on the northwest corner of the intersection of Main and Exchange Streets was built in 1889. It housed the Millers River National Bank. A fire in 1913 seriously damaged the ornate top of the building. The fire damage was removed and a fourth floor with flat roof was added. Visible along Exchange Street to the right are the original bank building and the Academy of Music Building. Today, the Athol Savings Bank is located here. (Carter's Postal.)

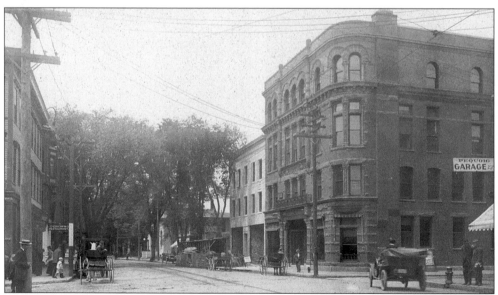

The modified Bank Block, with its new fourth floor, is seen in this view looking west on Main Street. The horseless carriage is beginning to replace the horse and buggy in this c. 1913 photograph. (Underwood & Underwood.)

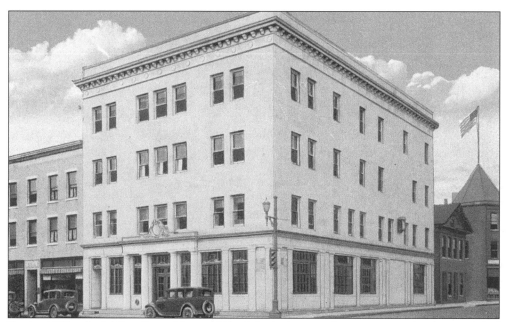

By the 1930s, the Millers River National Bank had taken on the appearance familiar to Athol residents of today. (Tichnor.)

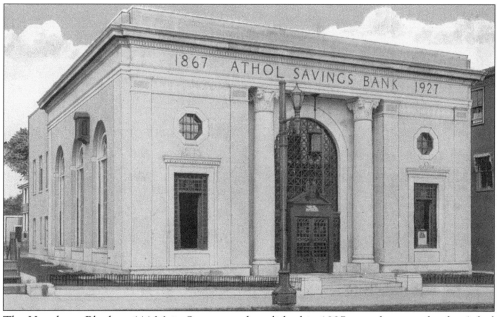

The Houghton Block at 444 Main Street was demolished in 1927 to make room for the Athol Savings Bank, which occupies the building to this day. The Bank is shown c. 1930. (Tichnor.)

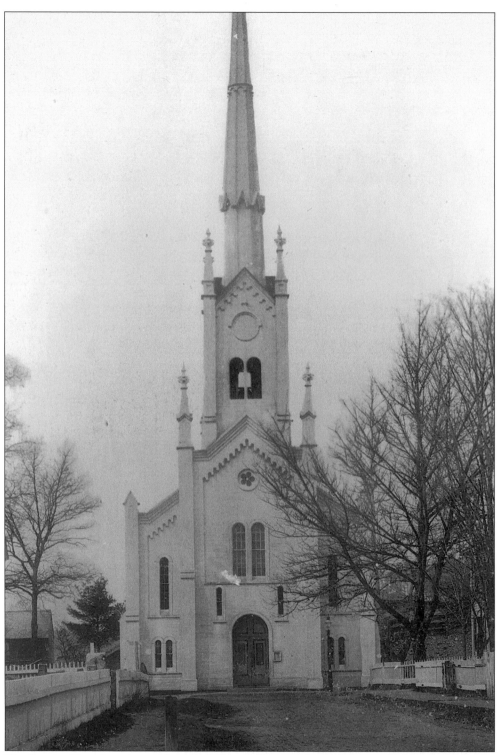

The Baptist Church at the north end of Church Street is shown here, *c.* 1880. The steeple was lost to the hurricane of 1938. It is now the Athol-Orange Baptist Church. (Lithotype.)

This Second Unitarian Church stood on the same site as the present First Church-Unitarian Universalist at 478 Main Street. It was built in 1881, and burned in 1912. (C.E. Ingalls.)

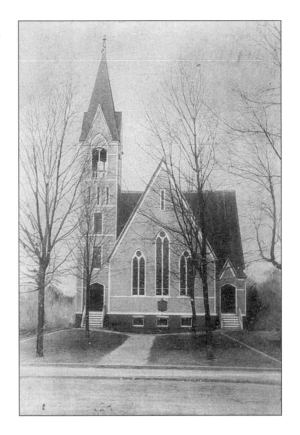

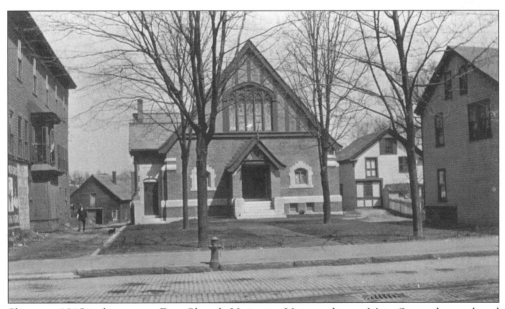

Shown c. 1915 is the present First Church-Unitarian Universalist on Main Street that replaced the church that burned in 1912. Notice the brick-paved Main Street and the trolley tracks.

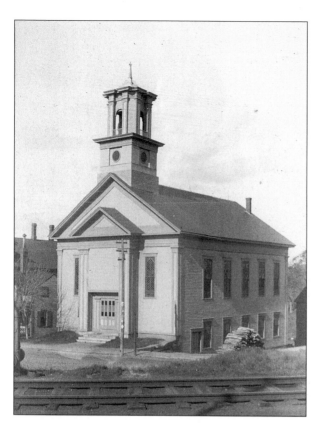

The Methodist Church stood at the corner of Main and Crescent Streets. It was first occupied in 1861 and was used by the congregation until 1918, when the new church on Island Street was completed. The L.S. Starrett Company now uses the site as a small parking area.

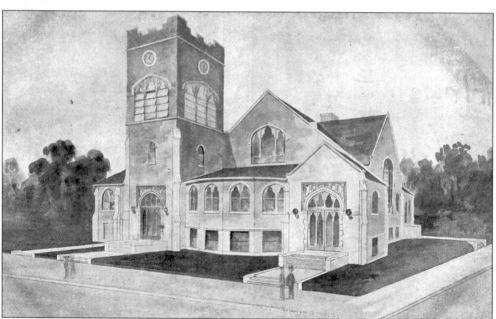

This artist rendering shows the present-day Starrett Memorial Methodist Episcopal Church at the corner of Island and Marble Streets. It was dedicated in 1918, when the congregation moved from its Main and Crescent Street location.

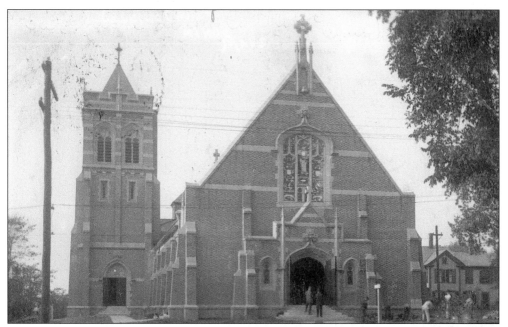

The cornerstone for the Church of Our Lady Immaculate (Catholic) on School Street was laid in October of 1904. The church was completed and dedicated one year later. It is shown here *c.* 1906 as workers construct the wall along the sidewalk.

F.W. Sandford was rector of the St. John's Episcopal Church at the corner of School Street and Park Avenue when this 1904 photograph was taken.

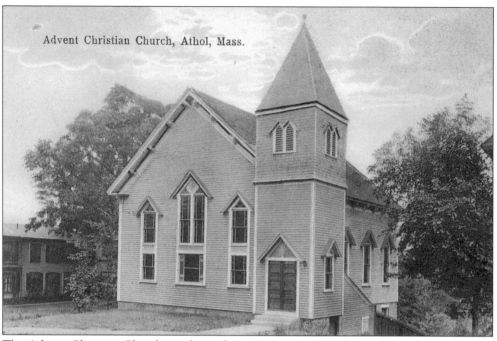

Advent Christian Church, Athol, Mass.

The Advent Christian Church was located at 1278 Main Street from 1871 to 1943. It is now Athol Grange Number 175. (Purdy.)

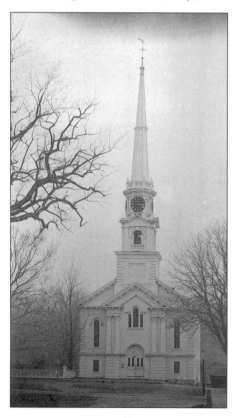

The Congregational Church on Chestnut Street near Main Street was built in 1833. It was extensively repaired and enlarged in 1859. It is shown here c. 1880. (Lithotype.)

Three
BUSINESS AND INDUSTRY

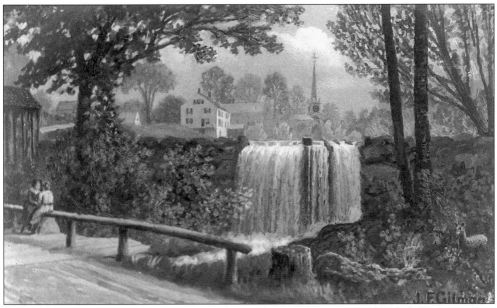

Waterpower was the chief source of energy used by industry prior to the use of steam power, both of which fueled the Industrial Revolution. Shown here in this 1912 painting by artist J.F. Gilman is a dam just off Hapgood Street. It was one of many dams throughout Athol that were designed to control the flow of water for use in powering the mills. The steeple of the Congregational Church is visible above the waterfall.

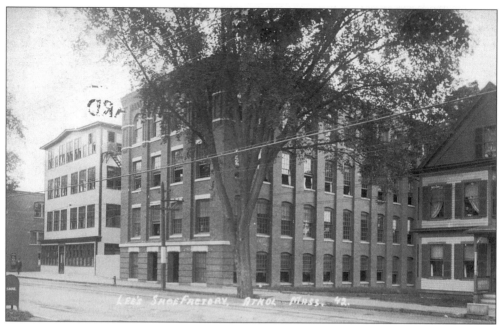

The Lee Brothers Shoe Company began in business in Athol in 1850. The Company moved to the location shown here at 349 Main Street in 1858. Beginning with the wooden building at the left, expansion concluded with the brick building at the right in 1910. The factory was later to become, successively, Ansin Shoe Company, Anwelt Shoe Company, and J.F. McElwain Shoe Company.

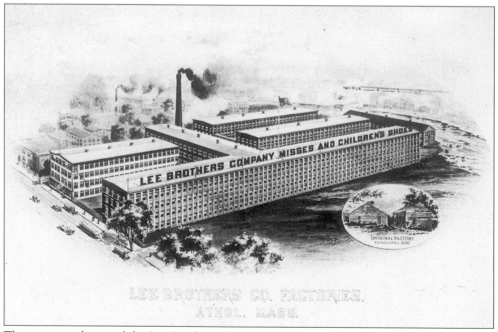

This artist rendering of the Lee Brothers Shoe Factory, though somewhat embellished, shows the extensive size of the facility. It stretched from Main Street on the left, nearly to South Street on the right. The rendering is *c.* 1918.

44

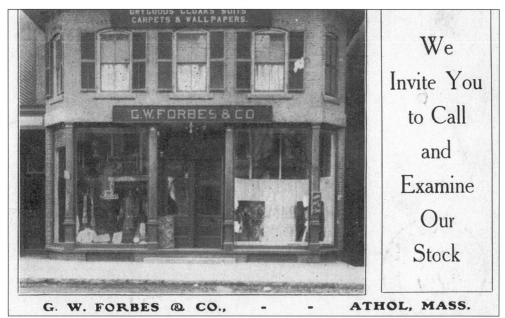

G.W. Forbes & Company purchased the dry goods store of Parmenter & Tower just before the turn of the century. It was located on Main Street near the west end of the currently proposed Veterans Memorial Park. The Company was in business here until 1914.

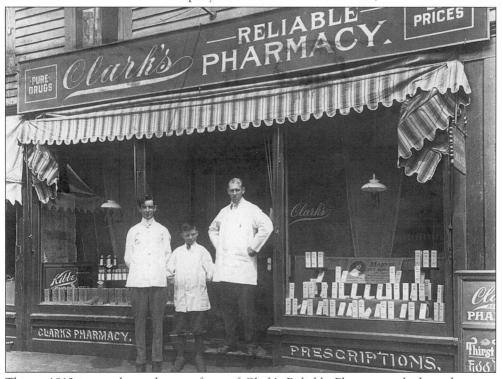

This *c.* 1913 image shows the storefront of Clark's Reliable Pharmacy, which at that time was located in the Houghton Block at 444 Main Street. It is now the location of the Athol Savings Bank.

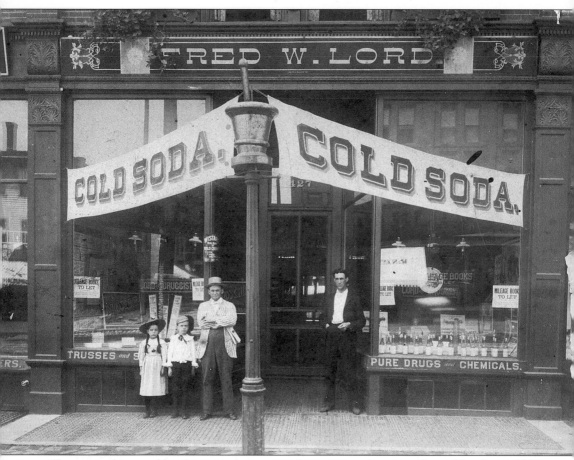

Then, as today, a cold soda was welcome on a hot summer day, as evidenced by this *c.* 1912 photograph of the Fred W. Lord drug store. The store was located in the Webb Block at 427 Main Street. The unmistakable reflection of the windows of the Pequoig House is evident in Lord's window above the right "Cold Soda" banner. Note the large mortar and pestle druggist symbol on the top of the pole to which the "Cold Soda" banners are attached.

The C.F. Richardson Machine Shop, shown here *c.* 1890, was located at the present-day site of the YMCA on Main Street. The Company manufactured levels, transits, and other tools but converted in later years to the repair of bicycles and automobiles. It was razed in 1910.

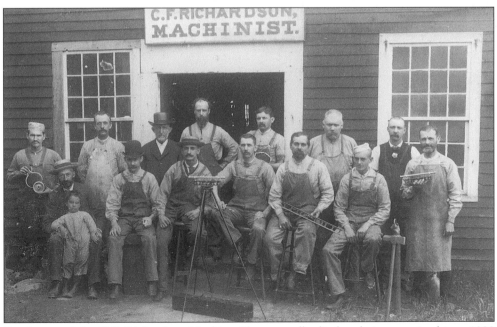

Employees of the C.F. Richardson Machine Shop proudly display their wares in this *c.* 1888 photograph. Identified at the far left holding calipers and a pulley is Mr. H.F. Bullard.

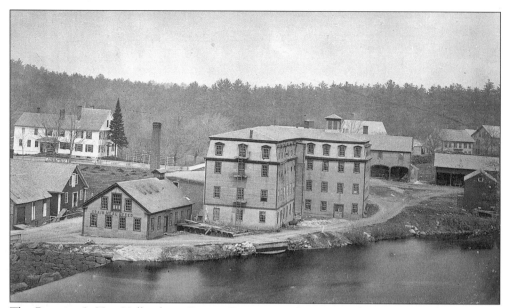

The Bennett & Van Valkenburg Cotton Factory, on the present-day site of the L.S. Starrett Company, is shown here *c.* 1879. The Company manufactured cotton cloth and yarn. The small building to the left with white trim still stands. (Lithotype.)

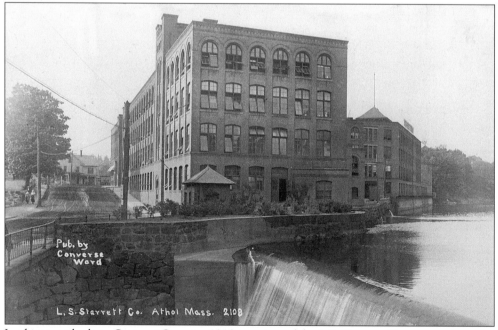

Looking north along Crescent Street *c.* 1910 is a view of the L.S. Starrett Company, where the Bennett & Van Valkenburg Cotton Factory once stood. The house on the left has since been removed, but the tiny flat-roofed building beside it still stands. It was the neighborhood grocery store of C.F. Hause at 154 Crescent Street. (Converse Ward.)

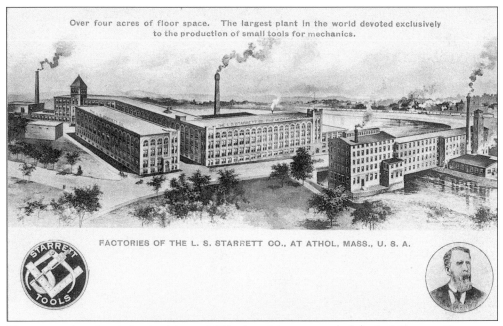

The power plant is missing in this pre-1908 advertising postcard of the L.S. Starrett Company.

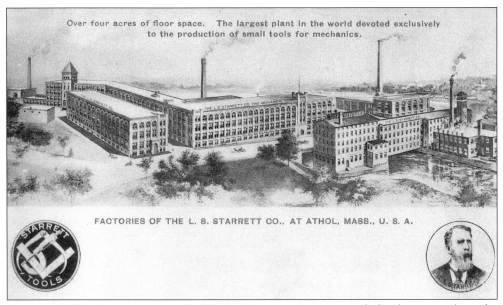

This post-1908 advertising postcard of the L.S. Starrett Company includes the power plant, the addition of two floors to the building to the right of the castle-like tower, and the enlargement of the structure at the right along the river. (Campbell Art.)

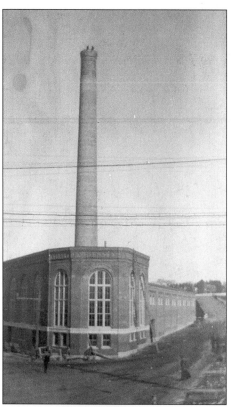

Two daring individuals are shown here at the top of the L.S. Starrett Company power plant chimney that rises to a height of 175 feet. The power plant was completed in 1908. This *c.* 1908 view looks east along a then unpaved Main Street.

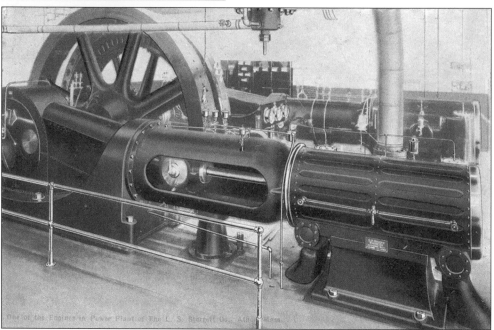

As the demand for more and more product grew after the turn of the century, water power was replaced with steam power. Shown here is one of the steam engines in the power plant of the L.S. Starrett Company, *c.* 1910. (Americhrome.)

50

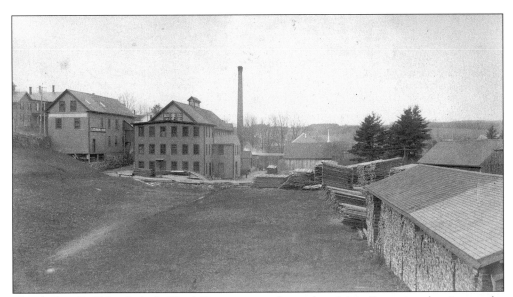

The Arthur F. Tyler Sash & Blind Company was located on Main Street in what is now the Athol Industrial Mall parking lot. This c. 1890 photograph looks west from the Chestnut Hill Avenue railroad bridge. The house at the left is at the corner of Riverbend and Main Streets.

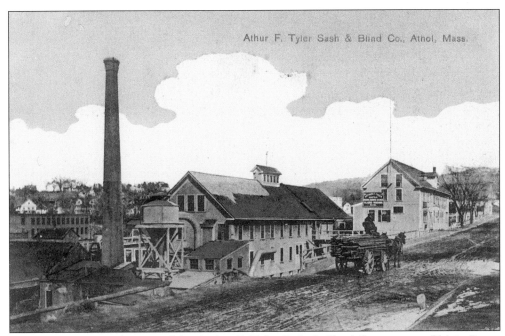

Athur F. Tyler Sash & Blind Co., Athol, Mass.

This c. 1910 postcard image of the Arthur F. Tyler Sash & Blind Company is of Main Street looking east. The building on the left with many windows is the Union Twist Drill Company. The houses above it are on Crescent Street. (Greene & Sawyer.)

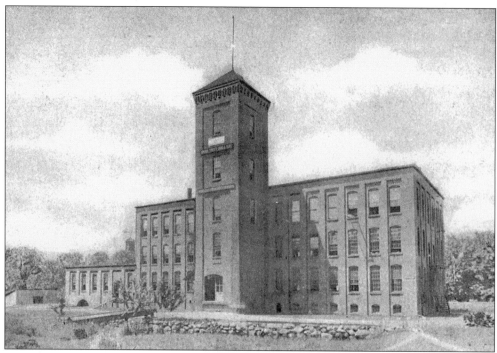

In 1905, a group of businessmen from Providence, Rhode Island, took over the interests of Gay & Ward on the Millers River at Monroe Street. Founded as the Union Twist Drill Company, it manufactured metal cutting tools at this location until the mid-1980s. This view shows the Company c. 1906. (C.E. Ingalls.)

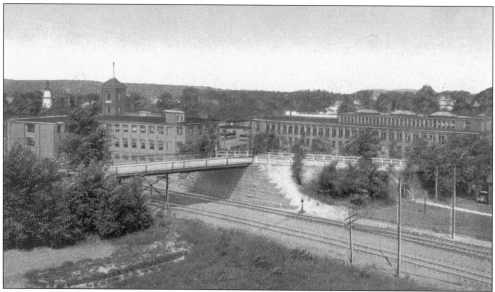

By 1930, the Union Twist Drill Company had risen to the position of Athol's second largest employer. This view looks northwest from Main Street. In the foreground is the Chestnut Hill Avenue railroad bridge. The white tower in the upper left was at 289 Crescent Street. The small building at the right with the automobile next to it was part of the Athol Manufacturing Company. (C.W. Hughes.)

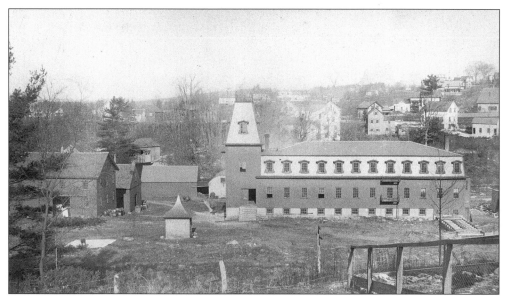

The Millers River Manufacturing Company, shown here *c.* 1890, was built in 1875. It stood in the now vacant lot across from the Chestnut Hill Avenue entrance to the Athol Industrial Mall. The Company manufactured blankets and, after being purchased by Laroy S. Starrett in 1915, artificial leather and coated cloths. Barely visible behind the pine tree toward the left is the covered bridge that spanned the Millers River. The houses to the upper right are at the east end of Crescent Street.

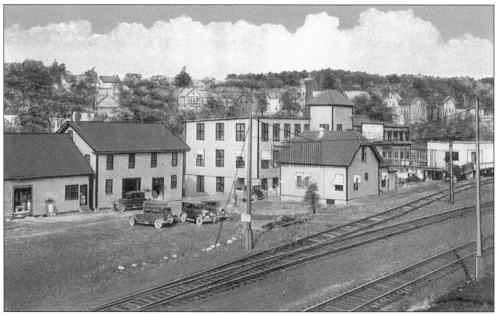

The Athol Manufacturing Company, earlier the Millers River Manufacturing Company, is seen *c.* 1930 in this postcard image looking northeast from the Chestnut Hill Avenue railroad bridge. Barely visible at the right is the profile of the original building that was built in 1875. (Tichnor.)

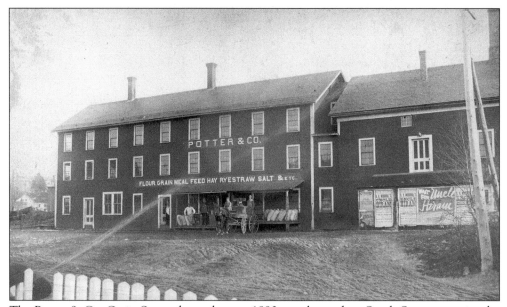

The Potter & Co. Grain Store, shown here *c.* 1890, was located on South Street opposite the end of Exchange Street. It is the present location of Ledgard's Warehouse.

The Eagle Furniture Company was established in South Athol. In 1881, the Company purchased land at 55 South Athol Road and erected the building shown in this photograph. Operations ceased in 1911, and the building was sold to the Cass Company to be used as a warehouse. The building burned to the ground in a spectacular fire *c.* 1990.

The J. Wesley Goodman Company, manufacturers of billiard and pool tables, moved from North Dana to occupy this facility at 167 Hapgood Street in 1873. It is shown here *c.* 1890. (H.F. Preston.)

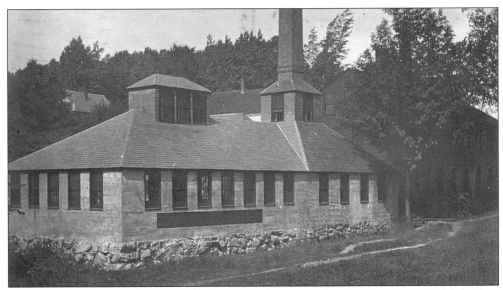

The Athol Pump Company operated a pump factory and foundry from 1891 to 1926. It was located in the triangle formed by Riverbend, Fletcher, and Hapgood Streets. It is shown *c.* 1910.

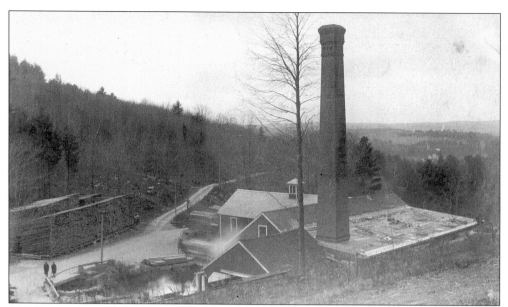

The Hapgood & Smith Match Factory was located near the convergence of Hapgood and Chestnut Streets where Mill Brook passes under a small bridge. Waterpower from Mill Brook was readily available at this location. The Factory produced match sticks, not the complete match. It is shown here *c.* 1890.

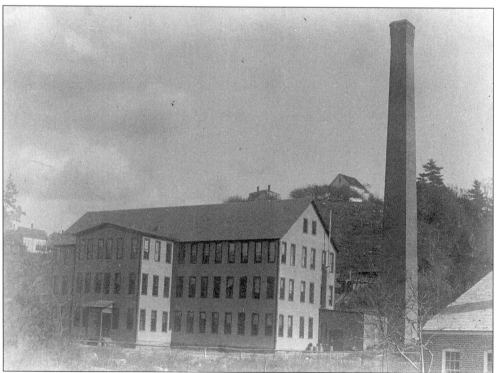

The Hill & Greene Shoe Factory, shown here *c.* 1890, was located on Chestnut Street just east of and to the rear of the Congregational Church. The houses above the factory are on Pleasant Street.

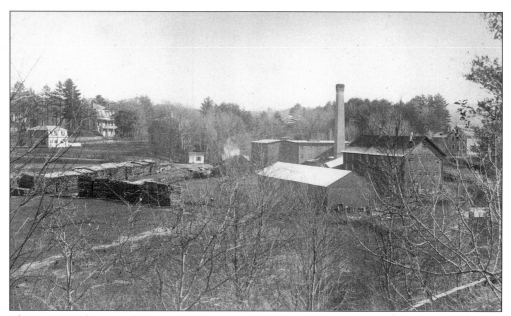

This *c.* 1890 photograph shows the factory of L. Morse & Sons at Mechanic Street. Morse & Sons manufactured furniture such as cribs, cradles, and tables. The business began to decline after its sale in 1935, and was removed in 1953.

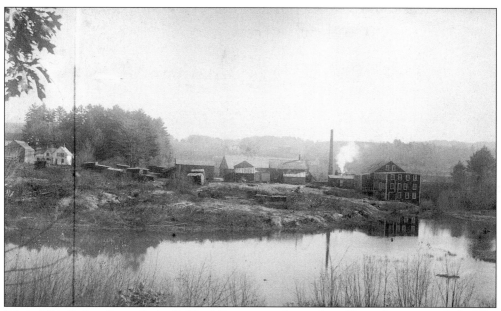

Edwin Ellis & Son Door, Sash, & Blind Factory was located on Water Street, now Lake Ellis Road near what is now Gibson Drive. It is shown here *c.* 1890.

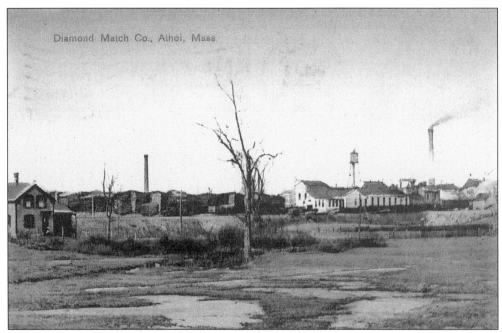

After purchasing the Edson Fitch Match Company (formerly Hapgood & Smith), the Diamond Match Company erected this factory on Harrison Street where Athol Table Manufacturing Company is now located. This *c.* 1908 view is looking north over the railroad tracks from South Athol Road. Notice the enormous stacks of lumber visible between the house at the left and the factory buildings. (Greene & Sawyer.)

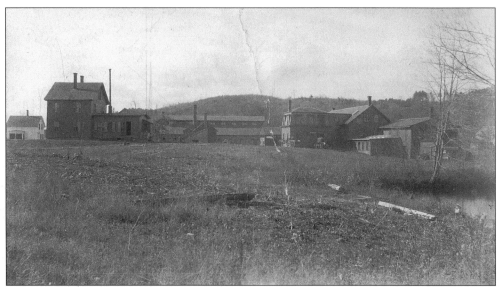

The Athol Machine Company, shown here *c.* 1890, was located at the west end of South Street. It was here that Laroy S. Starrett began his industrial enterprises with the manufacture of a household chopping machine that he had invented.

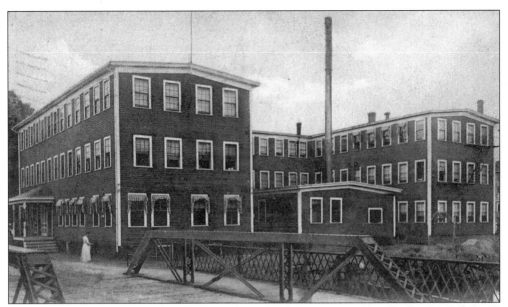

The Bates Brothers Wallet Shop was located on Island Street across from the Starrett Memorial Methodist Church. Shown here c. 1908, the company prospered at the site until declining sales and changing markets forced its sale at auction in 1932. The bridge in the foreground spanned a small branch of the Millers River that has since been rerouted.

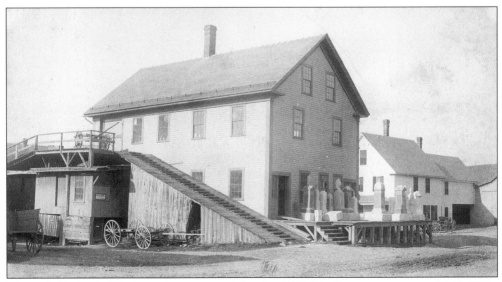

The Athol Marble Works at the corner of Island and Marble Streets was removed in 1917 in order to build the Starrett Memorial Methodist Church on the site. It is shown here c. 1890.

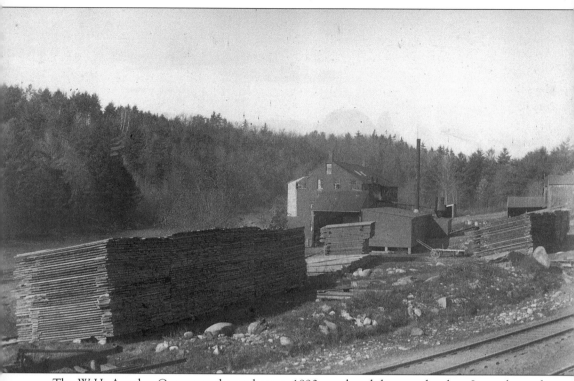

The W.H. Amsden Company, shown here c. 1890, produced doors and sashes. It was located in a remote location at the end of Kennebunk Street between the Millers River and the railroad tracks.

Four
TRANSPORTATION

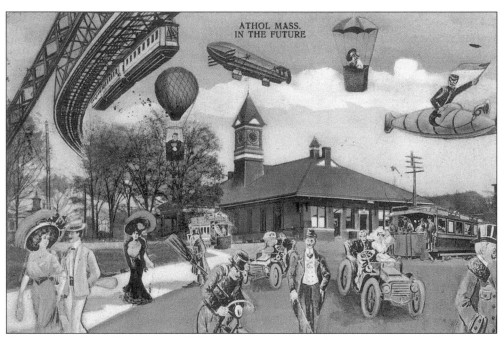

The creator of this futuristic *c.* 1909 postcard anticipated lively activity around the Athol Railroad Station. Included are many different kinds of futuristic transportation such as the automobile, aircraft, and trolleys. (W.B. Hale.)

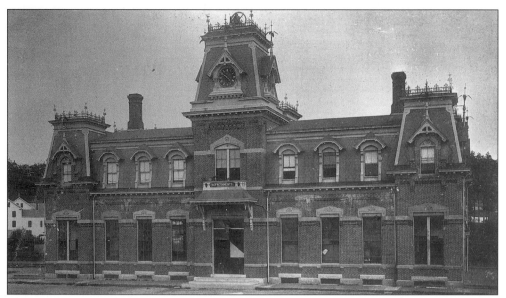

The railroad was the primary source for long distance travel from the mid-1800s to the mid-1900s. It provided relatively few stops and only at a single location—the railroad station. The Fitchburg Railroad Depot at Athol is seen in this *c.* 1880 photograph from South Street. (Lithotype.)

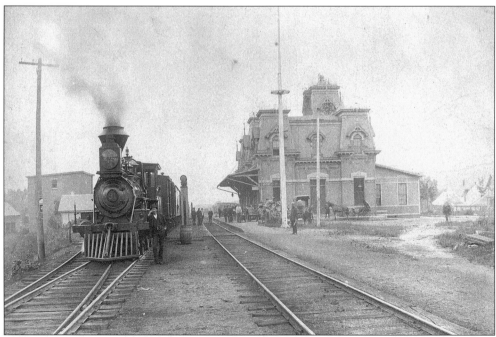

The Depot is seen here looking west *c.* 1890. A fire, which originated in the added kitchen extending to the right in the photograph, extensively damaged the building. The entire second floor and towers were destroyed in the blaze. (Moore.)

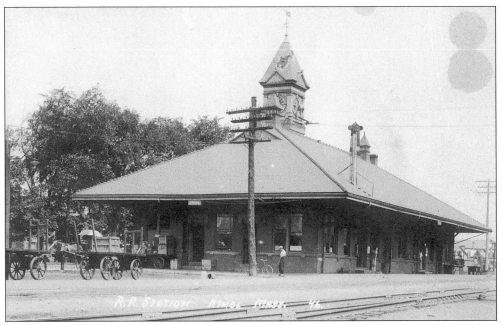

The Fitchburg Railroad Depot that burned in 1892 was replaced with the brick structure that stands today. This is the view passengers arriving from Orange and points west would see as they arrived at the station *c.* 1910. (Eastern Illustrating.)

On their way to the Railroad Station from South Street, travelers were greeted by a wonderful green park complete with cannon, *c.* 1918. (Eastern Illustrating.)

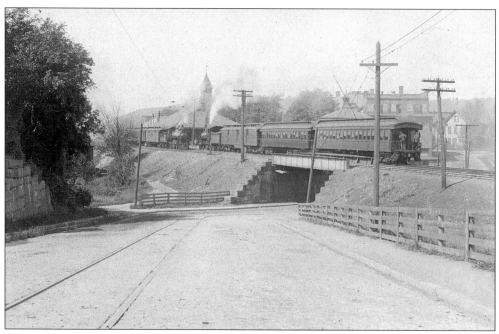

An eastbound (facing) and westbound train converge on the Athol Railroad Station in this *c.* 1906 view looking west on School Street. Trolley tracks of the Athol-Orange line are clearly visible on School Street.

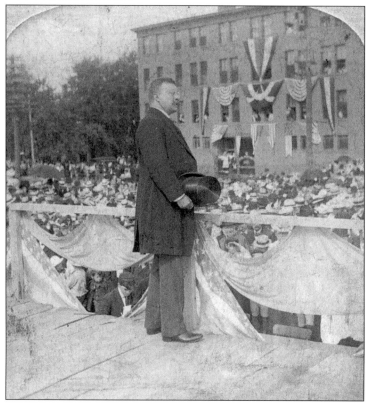

During the late nineteenth and early twentieth centuries, the railroad station was a focal point for many activities and visitors. Here, in 1902, President Theodore Roosevelt addresses citizens of Athol from a platform erected at the railroad station. The large building in the background is the Opera House that was located at the corner of South and Exchange Streets. (Underwood & Underwood.)

64

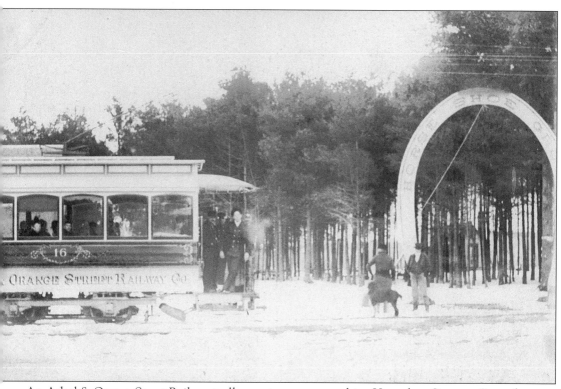

An Athol & Orange Street Railway trolley car is seen approaching Horseshoe Grove at Central Park (as Brookside Park was originally known). This photograph dates to *c.* 1895.

Wed' Sep' 19th 1894. Electric St Cars started f'm Orange on their first regular trips to Athol 6-30. AM. Cloudy and warm. Later—didn't get started 'till 7-10—Mrs. D.G. Goddard & I went on the first car No. 12 open car. Changed cars after we passed Central Park or Horseshoe Grove. Took car No. 11 open. Went to the Iron Bridge Athol & returned on the same car. Arrived in Orange 8 AM had a fine ride. We were the only <u>women on the trip</u>.

<div align="right">

S. E. Brown

</div>

Demand for more frequent and more direct transportation was fulfilled by the trolley. The excitement about the opening of the Athol & Orange Street Railway is evident in the words of a rider on the first trip from Orange to Athol and back in 1894. The text shown above was discovered in a note pad found at a local flea market. The reference to Central Park is Brookside Park (see page 90), and the Iron Bridge is the South Main Street Bridge (see pages 71 and 108).

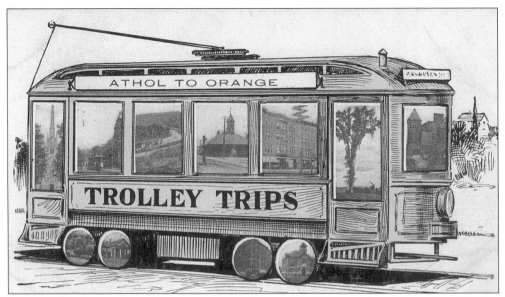

Rapid development of the electric motor made possible the creation of the trolley. Trolley travel from Athol Fair Grounds to Shelter Street in Orange was initiated in 1894. Though touting Athol to Orange trolley trips, this *c.* 1905 postcard displays images of Athol only. (Blanchard, Young & Co.)

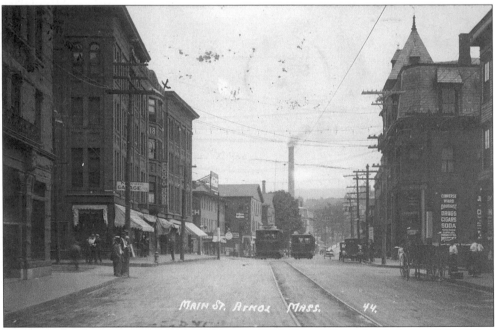

Two trolleys pass one another on Main Street, *c.* 1914. One trolley is headed toward the Athol Fair Grounds, the other toward Orange. Though only a single track connected Athol and Orange, one of the crossover tracks was located here in front of the Pequoig Block. (Eastern Illustrating.)

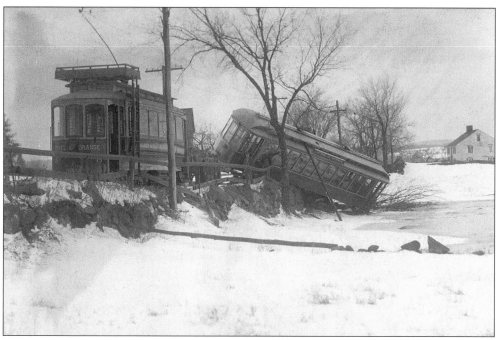

Though promoted as the modern means of transportation, trolley travel was not entirely without risk. Here, an Athol & Orange trolley awaits "rescue" after a derailment.

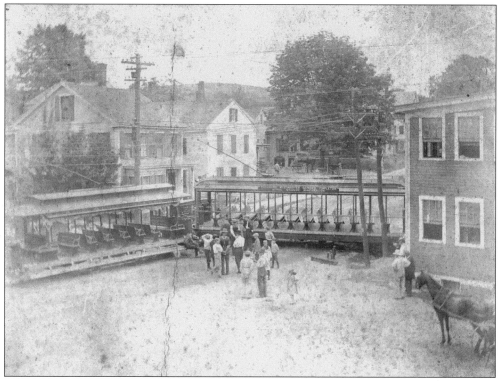

This trolley derailment took place on Main Street at the intersection of Pleasant Street. The location is directly in front of the present Citgo gas station. (Charles F. Smith.)

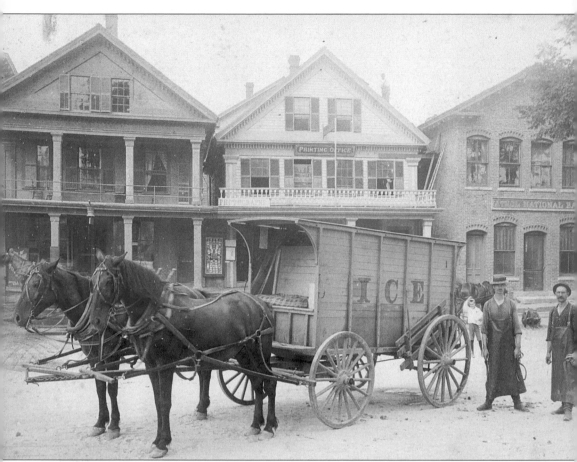

Horses were the primary means of local transportation before the turn of the century. Shown here, near the Summit House in Athol Center, is a typical delivery vehicle of the time. Ice was harvested during the winter months, cut, stored, and delivered during the warm months for the safekeeping of perishables. One icehouse in Athol was located on Lake Ellis Road, then Water Street, opposite Gibson Drive. This photograph is c. 1879. (A. E. Dunklee.)

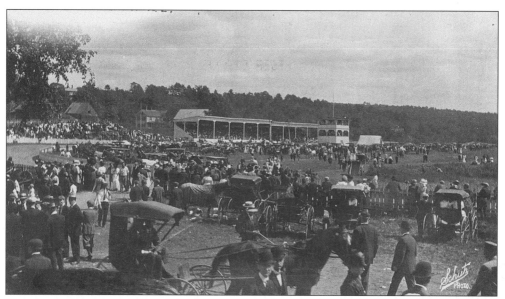

Horses and buggies were the predominant means of transportation to the fair, as shown in this 1912 photograph. The grandstand bordering Petersham Road is clearly visible. (Schutz.)

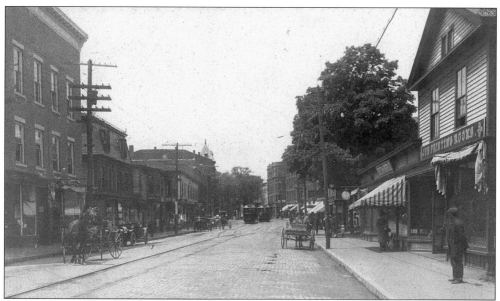

Changes in technology that affected how the citizens of Athol moved about locally are clearly illustrated in this wonderful view of Main Street looking west, c. 1914. Horses and buggies, automobiles, and trolleys can be seen. (Underwood & Underwood.)

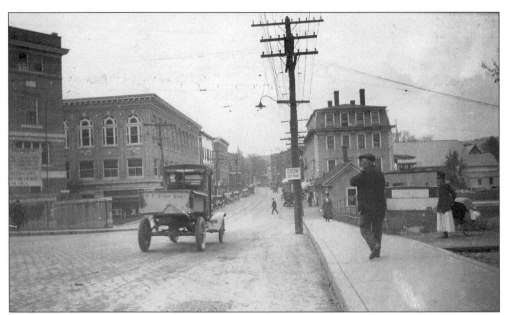

Horses and buggies are virtually unseen in this view of Main Street looking west from the front of the YMCA, c. 1918. A trolley can be seen near the Pequoig Block, but even its days were numbered, as the automobile became the preferred means of local transportation. Notice the brick-paved Main Street.

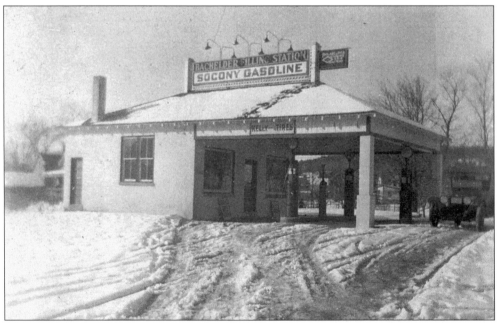

Changes in the appearance of Athol took place as the automobile began to proliferate. Gasoline stations were beginning to appear. By the mid-1930s, more than a dozen were scattered about the town. Early motorists filled their gas tanks at filling stations such as Bachelder's at 15 Main Street.

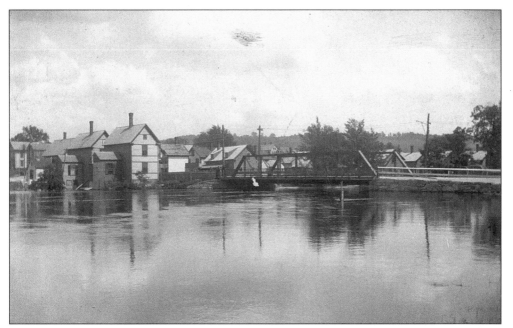

South Main Street Bridge from the north is seen here *c.* 1900. This is the area where the canoes are now staged for the annual River Rat Race from Athol to Orange.

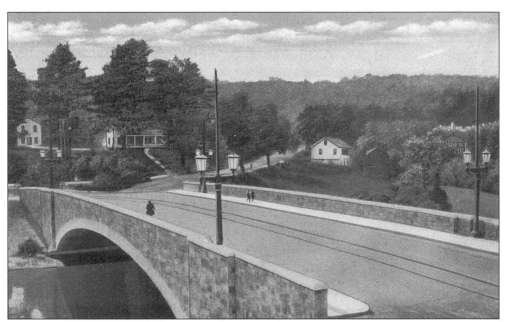

In 1922, the present-day concrete arch bridge replaced the steel girder South Main Street Bridge. Note the trolley tracks at the center of the bridge, removed long ago. North Orange Road bears off to the right past the bridge. (C.T. American Art.)

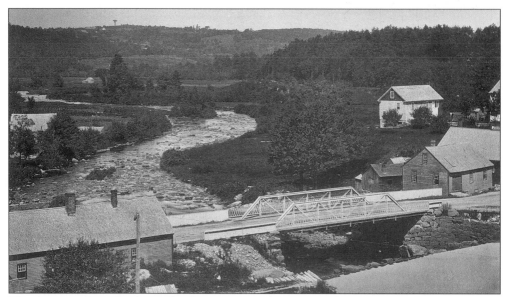

The Crescent Street Bridge at the dam is seen in this *c.* 1880 photograph looking west. Today, nearly the entire scene is obscured by the L.S. Starrett Company buildings. Notice the Sentinel Elm on the horizon. (Lithotype.)

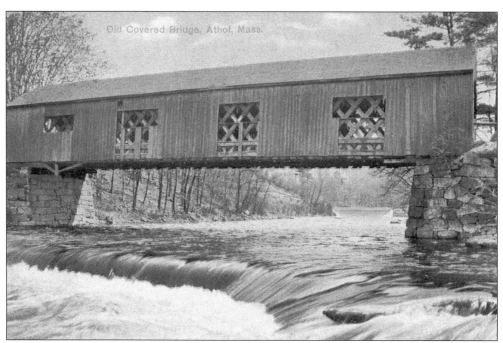

This covered bridge on Chestnut Hill Avenue spanned the Millers River between the Union Twist Drill Company and the Millers River Manufacturing Company. (Metropolitan News.)

Five
HOMES

The Athol Legion Home is pictured here, _c_. 1910. It was the home of C.L. Morse, who was mill superintendent of the D.E. Adams Silk Thread Company that was located on Lumber Street.

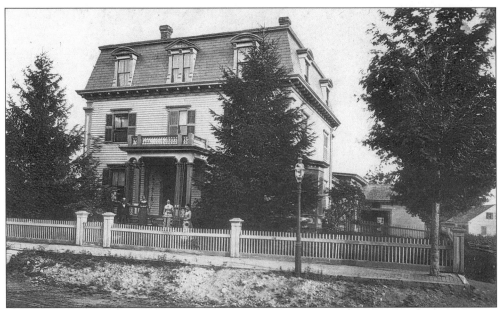

The George T. Johnson residence at 137 Main Street, shown here *c.* 1880, is now the J. Edward Murphy Funeral Home. Johnson was president of the Athol Machine Company. (Lithotype.)

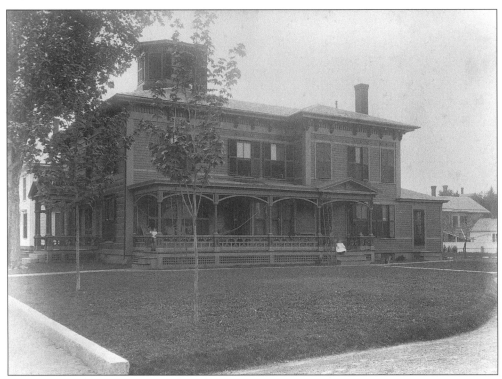

The home of George D. Bates of the Bates Brothers Wallet Company at 270 Main Street is shown here, *c.* 1890. It stood between Adams Chevrolet and the Athol Post Office. (H.F. Preston.)

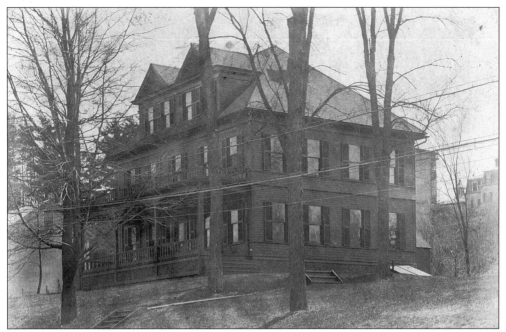

This house was at 925 Main Street. The stairs leading from Main Street are all that remains since it was razed in 1968. It was the 1903 birthplace of Athol's famed actor Charles Starrett, who played the "Durango Kid." It is shown here, c. 1907.

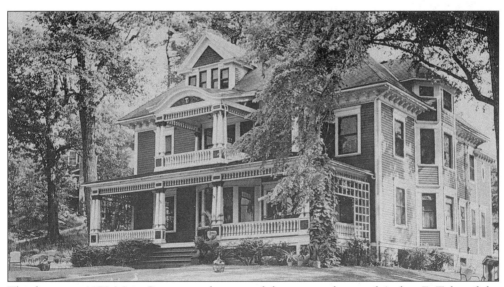

This house at 1179 Main Street was the turn-of-the-century home of Arthur F. Tyler of the Arthur F. Tyler Sash & Blind Company. It later became the Trade Winds guest house and gift shop and is again a private residence. (Meriden Gravure.)

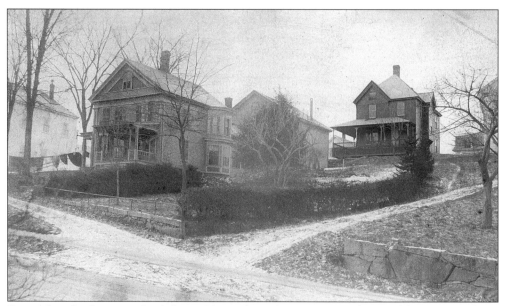

Pictured in the foreground at left, *c.* 1890, is the 1279 Main Street home of druggist Henry M. Humphrey. To the right is the home of newsdealer John H. Humphrey.

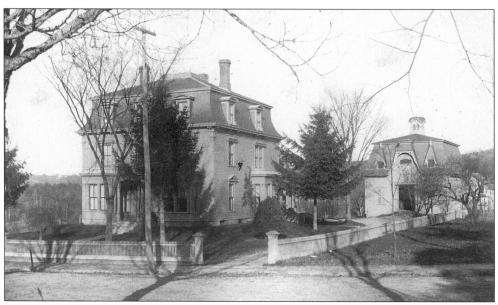

Mrs. C.A. Amsden owned this house at 1328 Main Street at the corner of Green Street, shown here *c.* 1890.

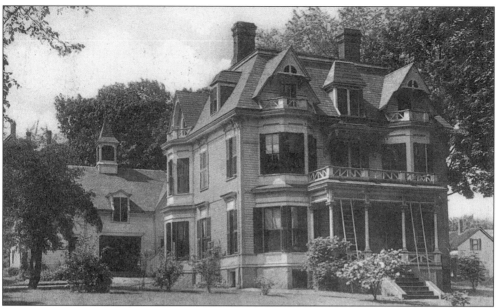

Solon W. Lee, lumber dealer, owned this house at 1333 Main Street, shown here *c.* 1909. It is presently the Laura Apartments. (W.B. Hale.)

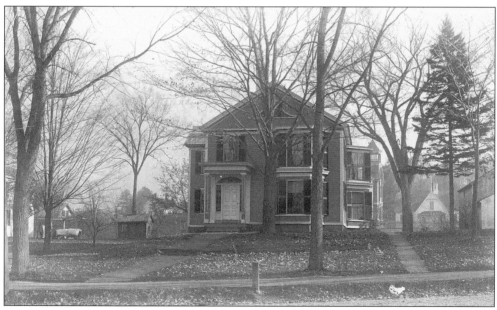

This house at 1422 Main Street was owned by Charles A. Chapman. Chapman was a cashier at the Athol National Bank. It is shown here, *c.* 1890.

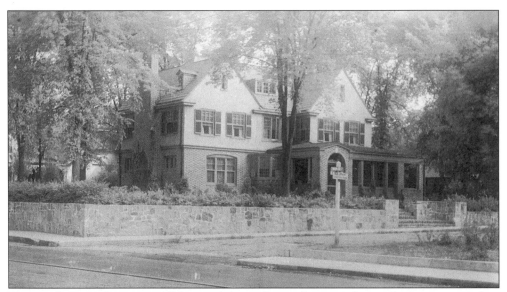

This residence at the corner of Main and Grove Streets has served several purposes, including that of a lodge for the Union Twist Drill Company and a restaurant. It is currently the North Quabbin Bible Church. This photograph was taken *c*. 1915. (Eastern Illustrating.)

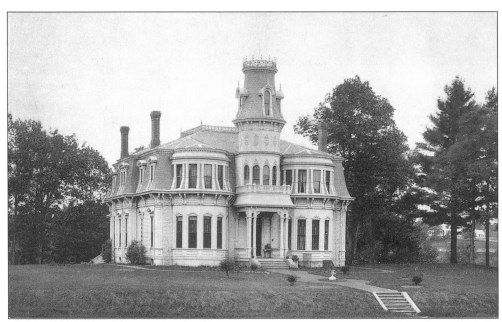

The Addison Sawyer residence at 2033 Main Street was razed in 1948 to make room for the Athol Memorial Hospital. A carriage shed at the rear of the house still stands and is used by the hospital. The house is shown here, *c*. 1880. (Lithotype.)

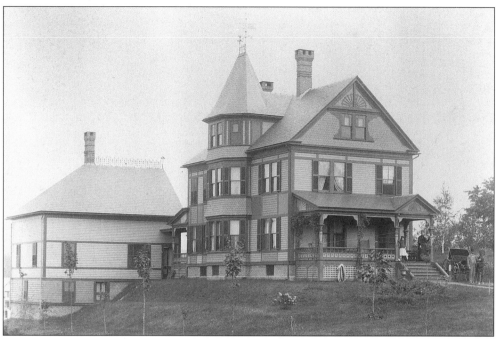

Shown here *c.* 1895, this house at 166 School Street was the home of George W. Bishop, who was roadmaster for the Fitchburg Rail Road. (H.F. Preston.)

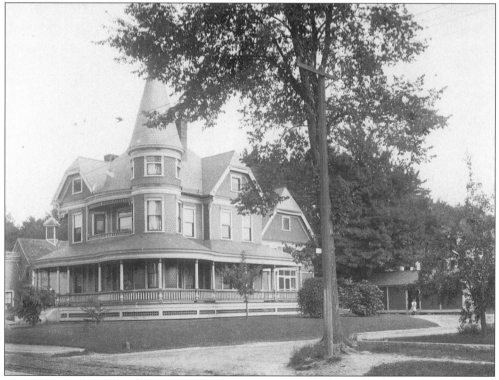

This house at 503 School Street was the home of lumber dealer Willard Newton. It is shown here, *c.* 1904.

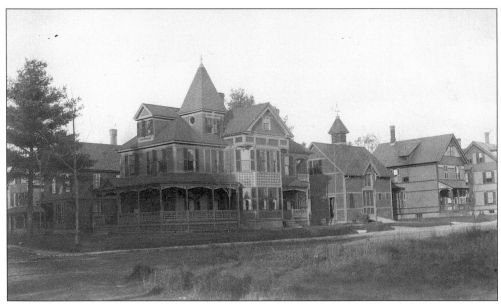

This house at 129 Union Street overlooks the east side of Fish Park. When this photograph was taken c. 1890, it was the home of Charles A. Bates of the Bates Brothers Wallet Company.

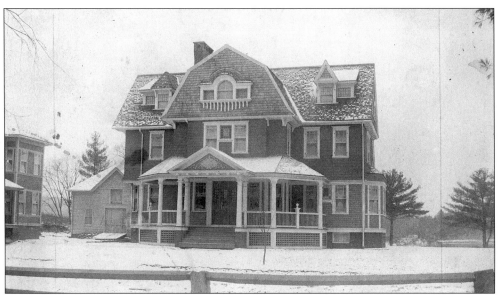

This house faces the northern end of Fish Park at 66 Newton Street. At the time of this c. 1890 photograph, it was the home of W.E. Wood, a local caterer.

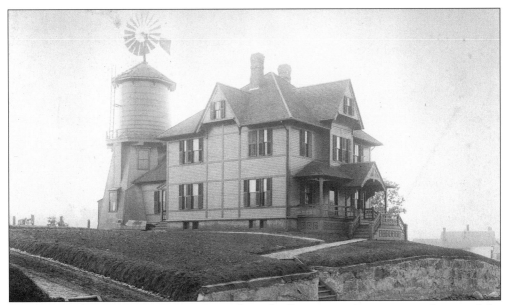

The large and quite ornate water tower and windmill constituted an imposing feature of the home of Augustus Coolidge at 289 Crescent Street. Coolidge was an insurance and real estate agent. This photograph dates to *c.* 1895. (H.F. Preston.)

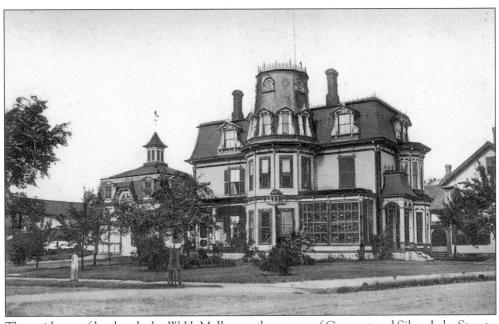

The residence of lumber dealer W.H. Mellen, at the corner of Crescent and Silver Lake Streets, appears in this *c.* 1908 image. It was on the present day site of Ron's Garage. (Gertrude Mellen.)

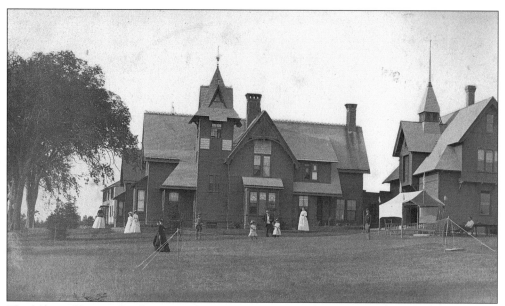

The home of Lucien Lord at 441 Chestnut Hill Avenue appears in this *c.* 1890 photograph. Lord was one of Athol's leading developers at the turn of the century. Among his numerous accomplishments were the construction of the Pequoig Block and the Academy of Music Building. He also developed the Lake Park area.

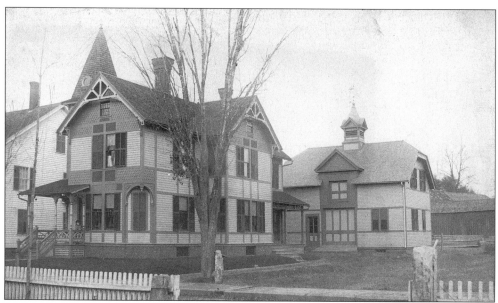

Converse Ward, a long time druggist in Athol, owned this house at 49 Church Street, shown here *c.* 1890. The house stood on land now used as a parking lot for the Athol Savings Bank.

Six

CELEBRATION,
RECREATION, AND PARKS

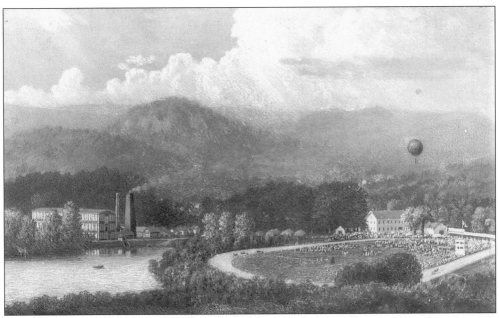

This bird's-eye view of the Athol Fair Grounds, by artist J.F. Gilman, shows that the early grandstand bordered Petersham Road. In later years, the grandstand bordered Lake Ellis. Raymond's Sash & Blind Company on Lake Ellis Road is at the left. The date is c. 1912.

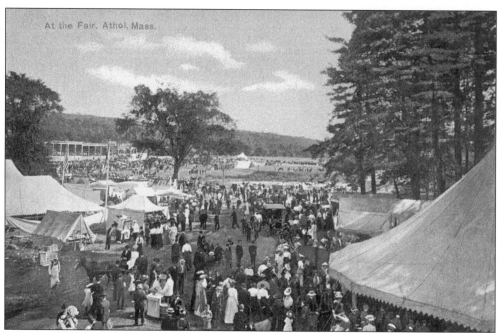

This overall view of the Athol Fair, *c.* 1912, was taken from the approximate location of the present-day Athol-Royalston Regional High School. (Metropolitan News.)

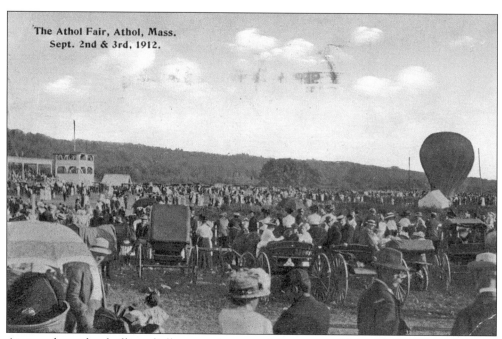

Air travel was the thrilling challenge at the turn of the century. Here, a balloon ascension was a center of attraction at the 1912 Athol Fair.

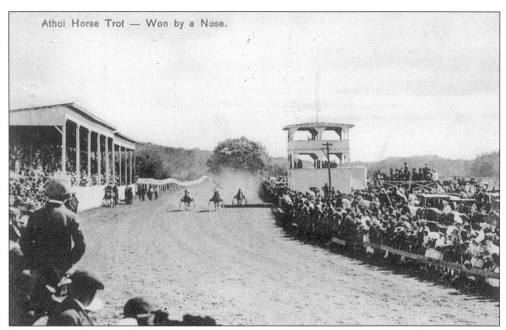

Athol Horse Trot — Won by a Nose.

Horses were not only a means of transportation, but a source of entertainment as well. The "X" marks the winner of this race at the Athol Fair Grounds "By a Nose!" (W.B. Hale.)

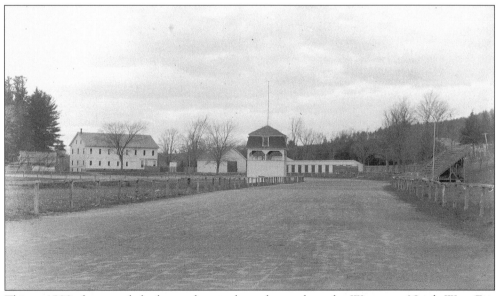

This c. 1890 photograph looks northwest along the track at the Worcester North West Fair Grounds, later called the Athol Fair Grounds. The exhibit hall at the left stands approximately on the site of the present day Athol-Royalston Regional High School.

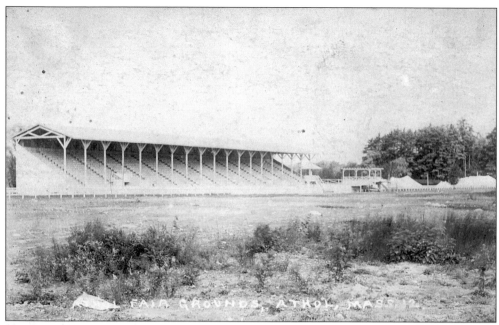

The "new" grandstand at the Athol Fair Grounds was constructed during World War I and bordered Lake Ellis. The original grandstand was on the opposite side of the track and bordered Petersham Road. (Eastern Illustrating.)

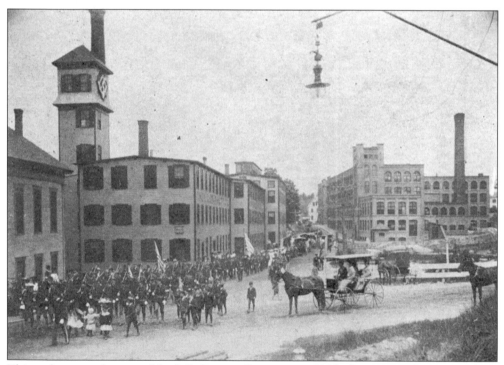

This early postcard image of the L.S. Starrett Company, c. 1905, shows a parade moving along Crescent Street about to turn right onto Main Street. At the left is the side of the Methodist Church that fronted on Main Street. (C.L. Wade.)

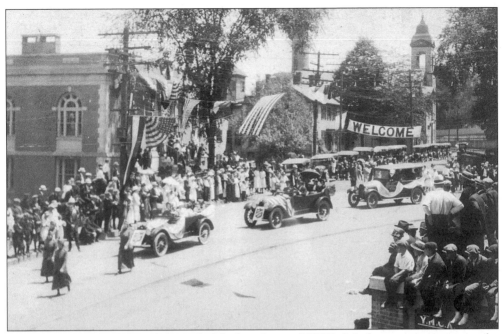

In 1918, the world celebrated the end of the hostilities of WWI. Athol was no exception, as the parade celebrating the return of the veterans is seen in these two photographs. Both were taken from the YMCA looking east. The recently completed Athol Public Library is visible at the left, but the Athol Memorial Building was yet to be constructed. Beside the "Welcome" banner is the steeple of the Methodist Church at the corner of Main and Crescent Streets.

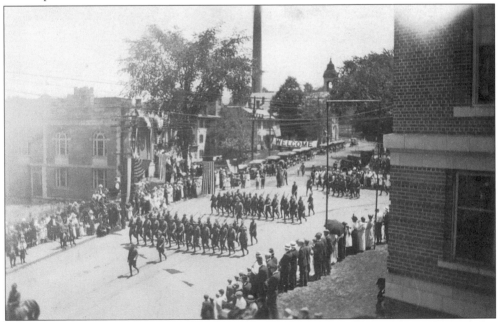

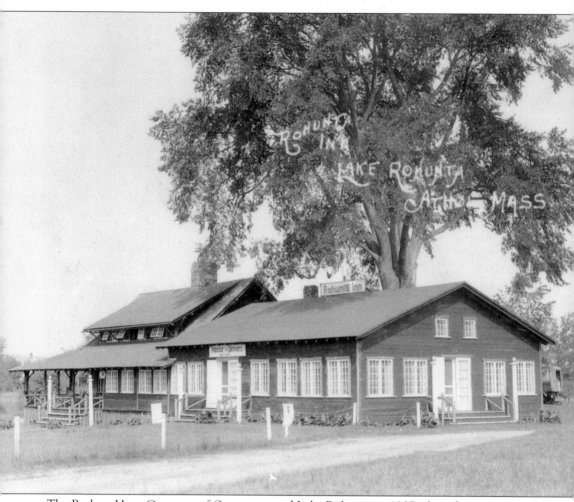

The Rodney Hunt Company of Orange created Lake Rohunta in 1907 when they constructed the dam that is now at the northern end of the lake just off Route 202. Outflow from the dam was used to generate electricity for their plant in Orange. It is located just north of Route 202 opposite the dam. The company then created a recreation facility on the shore of the lake that included an inn, cottages, and a sandy beach. The recreation area flourished until about 1940. The Rohunta Inn at Lake Rohunta is seen here, *c.* 1928.

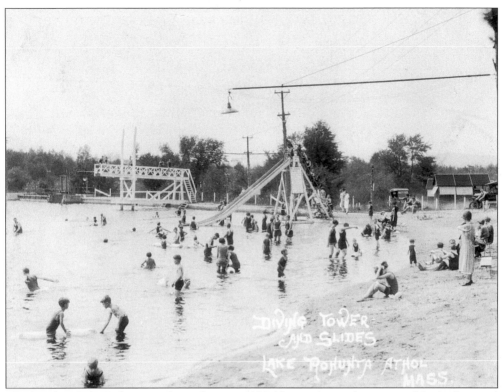

The beach at Lake Rohunta is shown here, *c.* 1928. Notice the modest attire of the bathers and the high diving board at the left.

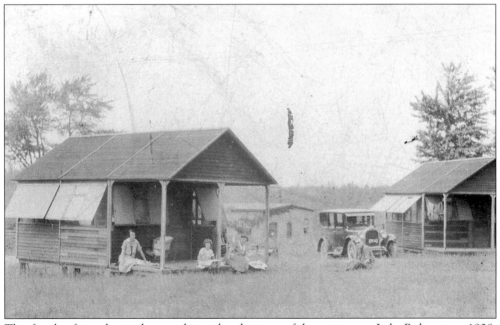

This family of travelers is shown taking a break at one of the cottages at Lake Rohunta, *c.* 1928.

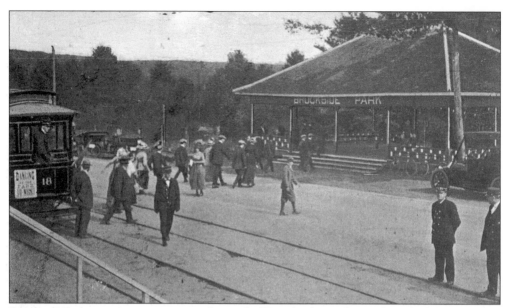

Brookside Park was a recreation center located off Brookside Road near the Athol-Orange town line. It was promoted heavily by the Athol & Orange Street Railway Company, as the trolley line traversed Brookside Road. The entrance is seen here in this *c.* 1912 view. (G.P. Harrington.)

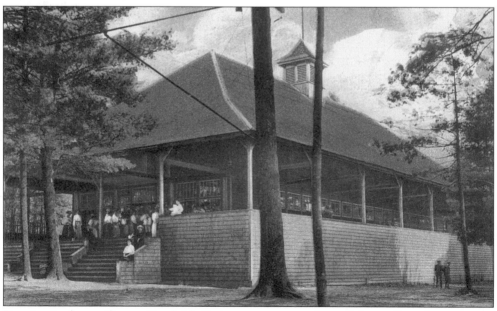

Dancing in the pavilion at Brookside Park was a very popular activity on Saturday evenings. This image of the pavilion is *c.* 1911. (W.B. Hale.)

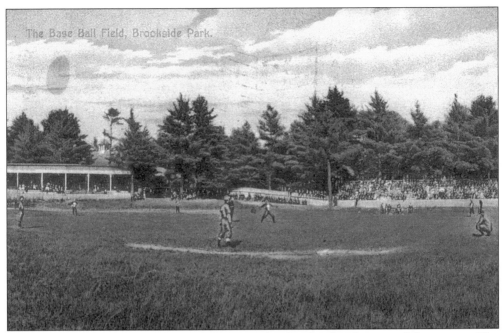

Baseball games at Brookside Park were very popular shortly after the turn of the century. The game pictured here is *c.* 1910. (W.B. Hale.)

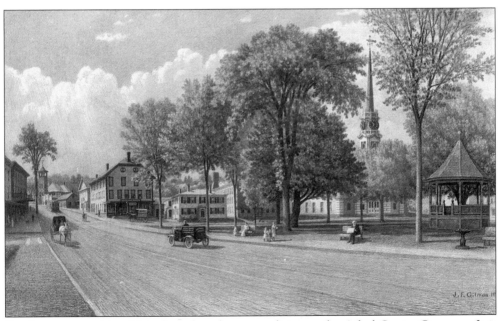

Band concerts and local fairs have long been a tradition at the Athol Center Common. It is shown here in this painting by artist J.F. Gilman in 1912.

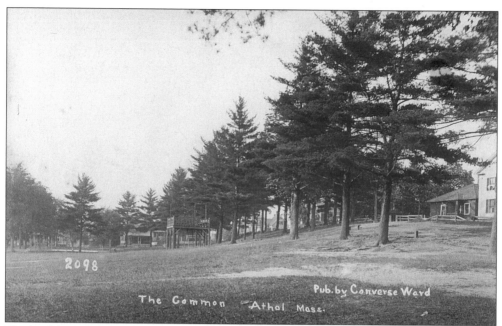

The land for Fish Park was donated to the town for public use by Mrs. Sally Fish, *c.* 1850. This photograph looks at the park from Walnut Street, *c.* 1910. Note the absence of the familiar bandstand and tennis courts at the far end of the park. Union Street is at the crest of the hill to the right. (Converse Ward.)

This postcard image of Fish Park looks northwest from Walnut Street, *c.* 1909. Maple Street lies beyond the fence. The large house at the left was razed in 1999. (Hugh C. Leighton.)

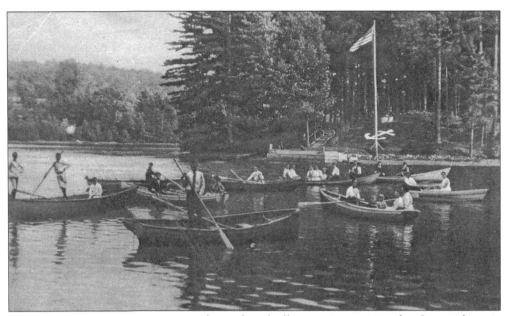

Lake Ellis was an attractive spot to relax and cool off on a warm summer day. Its popularity is evident in this c. 1908 view of boaters on the lake. (W.B. Hale.)

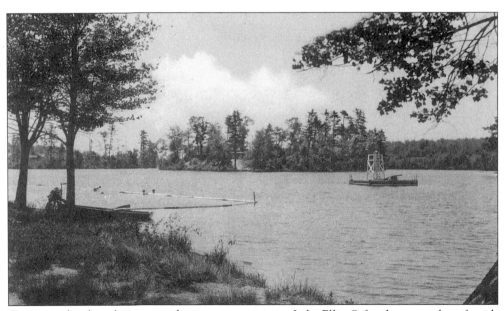

Swimming has long been a popular summer activity at Lake Ellis. Safety booms and a raft with a high diving board are seen in this view of the beach. (Collotype.)

Silver Lake, shown here *c.* 1909, became a very popular retreat for Athol residents, with swimming in the summer and ice skating in the winter. This view looks southeast. The smokestack of the L.S. Starrett Company is barely visible toward the right-center. (C.E. Ingalls.)

The Athol Sportsmen's Club created Sportsman's Pond in 1893 by constructing a dam on Goddard Brook that flooded the area known as Hackmatack Swamp. The dam can be seen near the center of this *c.* 1907 image. (Metropolitan News.)

Seven

ATHOL'S 150TH CELEBRATION

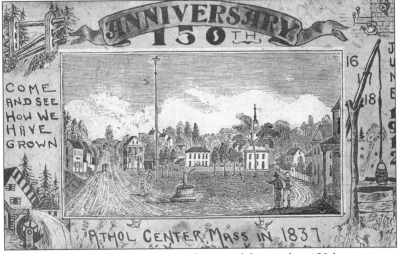

June 16, 17, and 18, 1912, were set aside to celebrate the 150th anniversary of the incorporation of the town of Athol. Activities on Sunday, June 16, included special services in Athol churches, choral singing, open-air addresses, and band concerts.

Monday the 17th was the centerpiece day of the celebration, with a gigantic parade commencing at 10:30 a.m. The parade consisted of marching units, horse-mounted units, bands, and floats. A crowd, estimated at over 20,000, viewed the parade! After the parade, there were baseball games, foot races, and wrestling matches. The day concluded with a fireworks display. Activities on Tuesday the 18th included automobile tours of Athol, baseball games, and historical addresses. The celebration concluded with a Grand Anniversary Ball at Brookside Park.

The postcard image commemorating the celebration depicts Athol Center in 1837. The pump stands at the site of the Twichell Fountain at the Common. The Congregational Church appears toward the right.

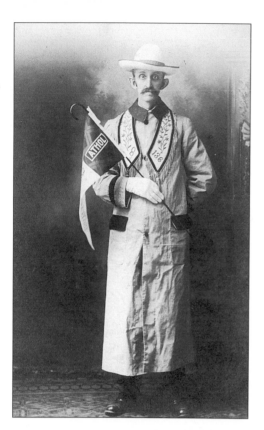

Dressed in preparation for marching in the parade is a member of the Tully Independent Order of Odd Fellows (IOOF), Lodge 136. (Clapp & Ingalls.)

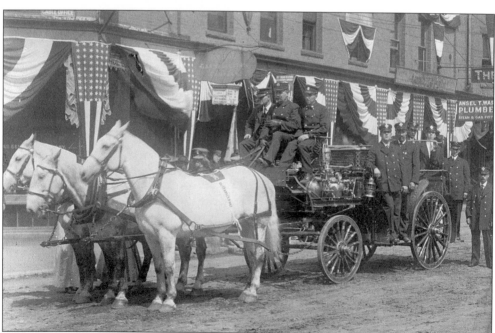

Firefighters prepare for the parade in front of the Academy of Music Building next to Athol Fire Station No. 1 on Exchange Street.

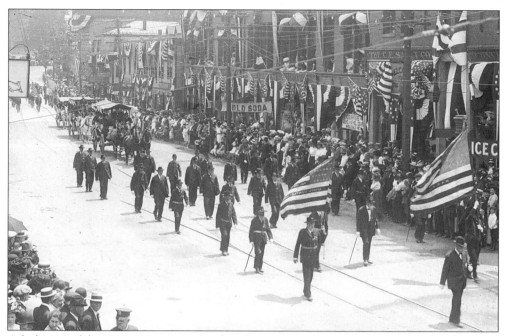

Athol posts of the GAR were represented in the parade.

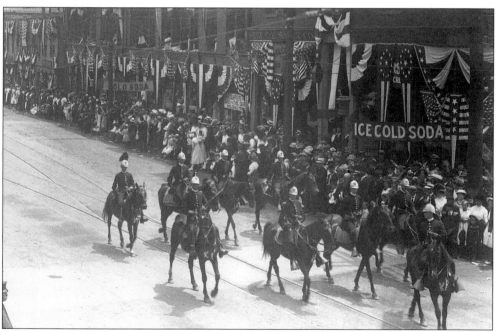

No parade would be complete without horse-mounted units. One of many in the parade is shown here.

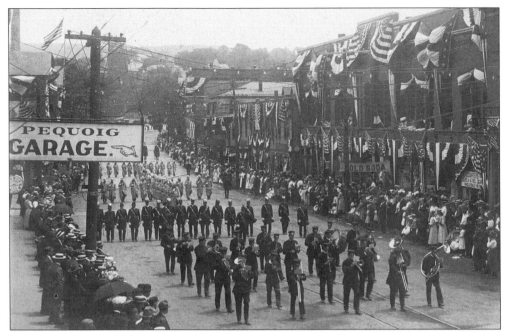

Tully IOOF, Lodge 136 marchers were preceded by this band, shown as the parade along Main Street approaches Exchange Street. The "Cold Soda" sign is in front of the Fred W. Lord drug store in the Webb Block.

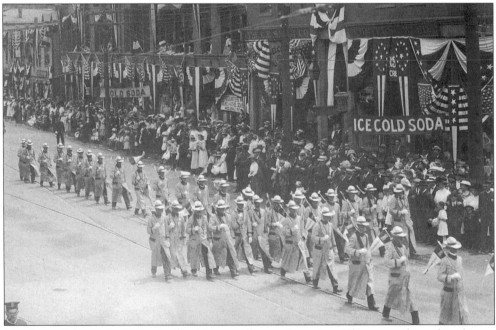

Marchers of the Tully IOOF, Lodge 136 proudly pass in review. They were dressed in dusters with red trim and straw hats.

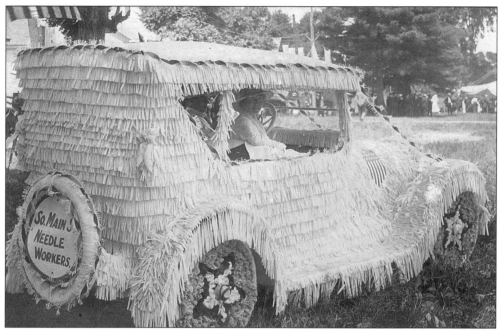

The South Main Street Needle Workers were represented in this highly decorated automobile.

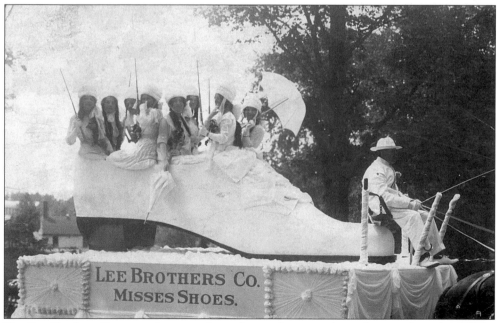

The Lee Brothers Company float was drawn by two horses and was decorated in white. Eight young women dressed in white and carrying parasols rode in the shoe.

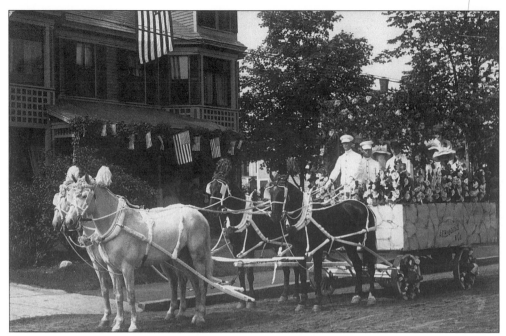

The J.F. Higgins Company float was drawn by two black and two white horses. The wagon sides were decorated like a stone wall and were trimmed with flowers. Eight people representing various nations rode in the float.

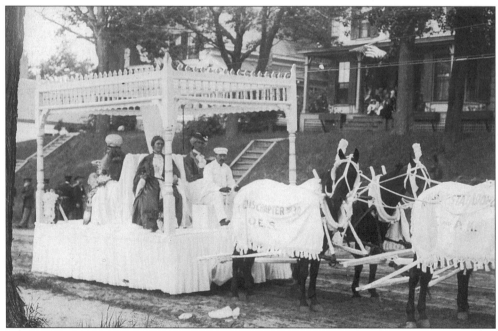

The highly ornate Masonic bodies float was drawn by four horses with blankets lettered with gilt. The Eastern Star was represented as Queen Esther by Mrs. D. Fay Pratt. John E. Clark, as George Washington, represented Starr and Athol Masonic Lodges. Harry Beecher, as King Solomon, represented the Union Royal Arch Chapter. The Athol Commandery was represented by L. Knechtel portraying a knight in armor (not visible in photograph.)

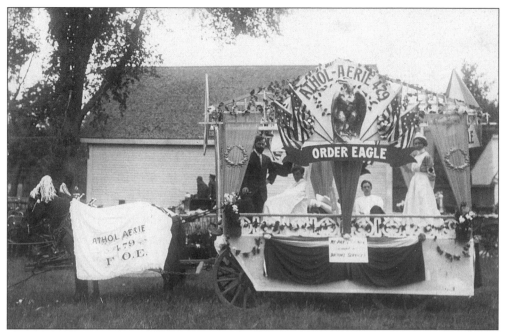

The Athol Order of Eagles float was decorated in blue and white and was adorned with two gold eagles on its sides. It represented a hospital scene with doctor, nurse, and patients.

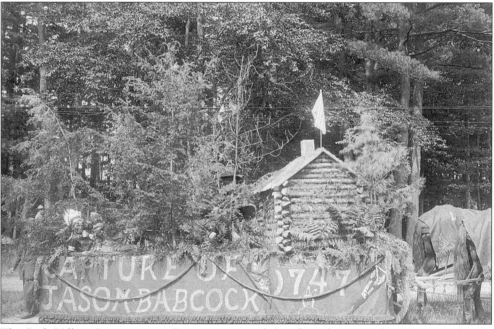

The Park Village Improvement Society sponsored this float depicting the "Capture of Jason Babcock." In 1747, Babcock, an Athol farmer, was captured by Indians and held captive somewhere in Canada before his release a year later. Two Indians can be seen hiding among the brush near a log cabin on this cleverly designed float. It won first prize for the best historical presentation.

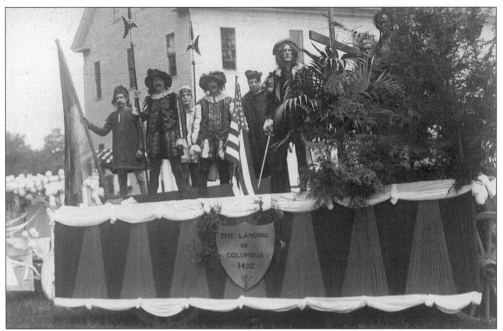

"The Landing of Columbus 1492" was the title of the Knights of Columbus float.

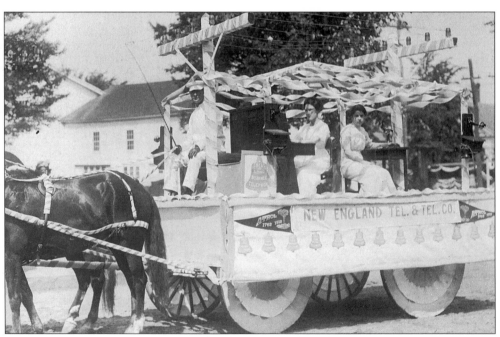

Drawn by two horses, the New England Telephone Company float depicted a modern telephone exchange. At the switchboard was Lena Hack, with Anna Barry at the receiver. The float was decorated in purple and white.

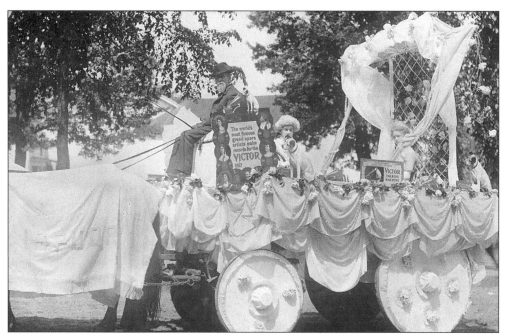

The float of musical apparatus dealer I.S. Purdy centered on the Victor Talking Machine.

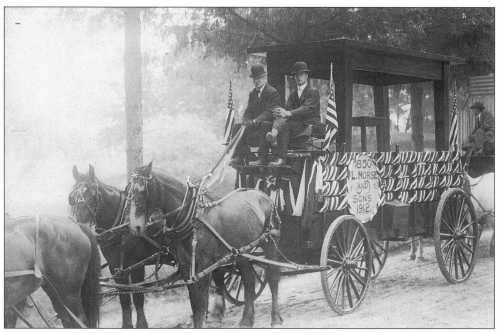

L. Morse and Sons, furniture manufacturers, displayed huge representations of their products on their float.

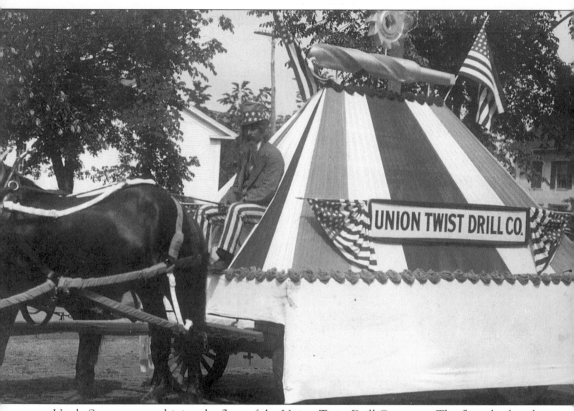

Uncle Sam was seen driving the float of the Union Twist Drill Company. The float displayed a huge milling cutter and twist drill.

Eight
AROUND ATHOL

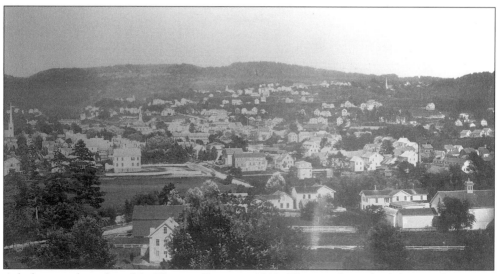

Athol is seen here from Mt. Pleasant Street, *c.* 1880. The steeple to the left is on the Baptist Church on the north end of Church Street. The steeple barely visible at the upper right is on the Congregational Church on Chestnut Street near Main Street. (Lithotype.)

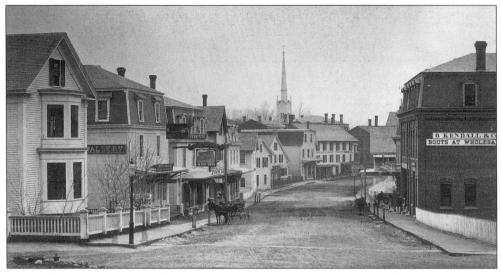

Very little looks familiar on Exchange Street looking north from South Street, *c.* 1880. The steeple is on the Baptist Church on Church Street. (Lithotype.)

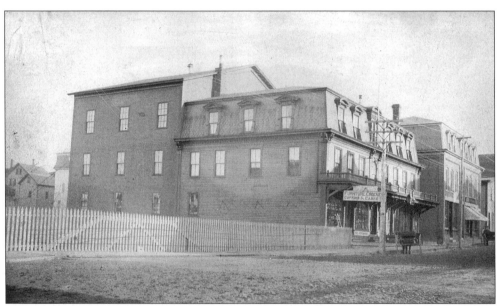

The Cardany Block at 33-41 Exchange Street was built in 1872 where Mr. Cardany established a furniture, crockery, and undertaking business. The large addition to the rear was added in 1888. It contained meeting rooms used by the IOOF, Daughters of Rebekah, and others. Plotkin's Furniture occupies the building today.

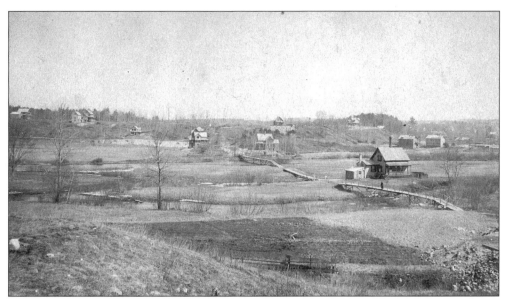

This view, looking north from the Academy of Music Building on Exchange Street in 1892, shows a relatively undeveloped landscape. The fire station, built in 1893, is missing, as is the Exchange Street Bridge. Before the bridge, the wooden footbridges shown here crossed the Millers River. By 1895, a bridge had been built and was replaced in 1939 by the present Exchange Street Bridge. Exchange Street Hill appears as nothing more than a dirt path at the center of the photograph.

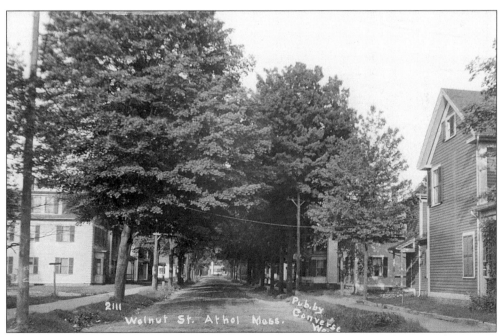

This view is of Walnut Street looking east from Union Street, as it appeared c. 1915. (Converse Ward.)

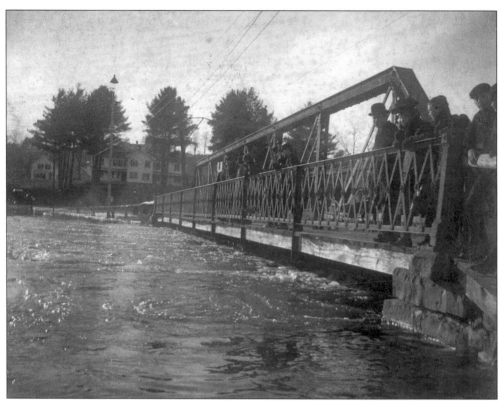

Peering off South Main Street Bridge *c.* 1900, these folks had yet to conceive of the Birch Hill and Tully Dams.

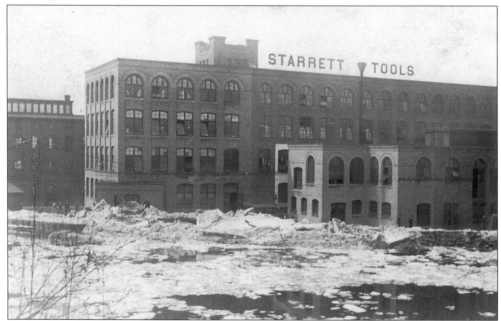

"Winters aren't what they used to be," may be true when looking at this ice jam on the Millers River at the L.S. Starrett Company dam.

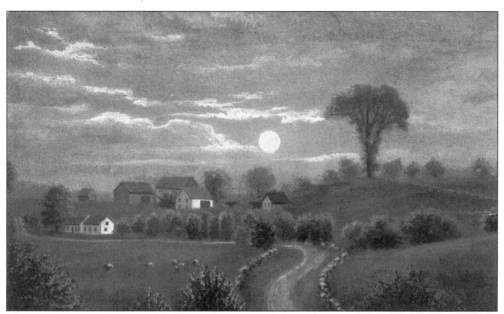

This painting, attributed to J.F. Gilman, shows a portion of Moore Hill Road with the Sentinel Elm to the right. The tree provided a stately watch over Athol until it fell in 1931.

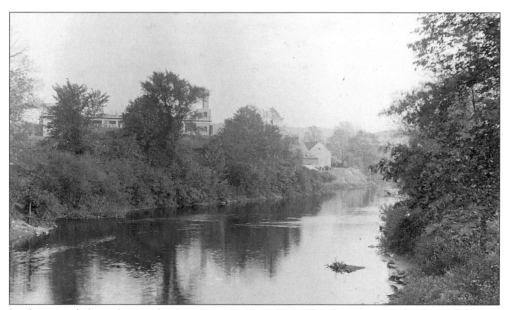

Looking south from the South Main Street Bridge, the Millers River prepares to leave Athol on its journey toward Orange. At the left is the Athol Machine Company at the end of South Street. The scene is c. 1915. (Converse Ward.)

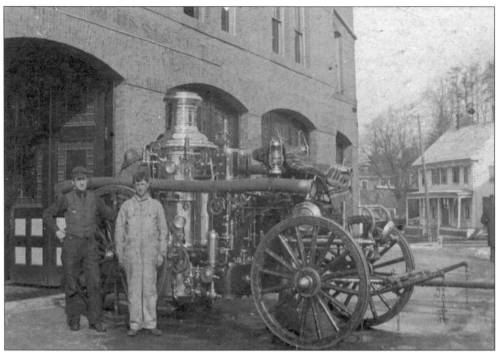

Athol firefighters pose with a horse-drawn steamer in front of Athol Fire Station No. 2, *c.* 1900.

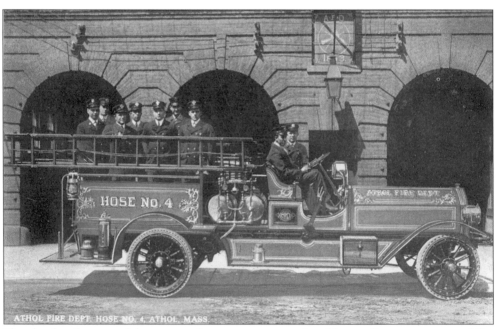

Shortly after the turn of the century, horse power was replaced by gasoline power to speed fire fighting efforts. Here, Athol firefighters proudly display Hose No. 4. It was the first mechanized piece of equipment in Athol, *c.* 1914. (C.T. Photochrom.)

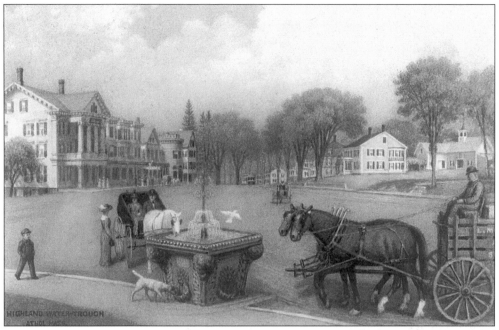

The Twichell Fountain at the north end of the Athol Center Common, which remains to this day, is the central focus of this *c*. 1912 painting by artist J.F. Gilman.

Support for the war effort during WWI was partially financed through the sale of Liberty Bonds. A rally at the L.S. Starrett Company to promote Liberty Bond sales is shown in this *c*. 1917 postcard image. (Curt Teich.)

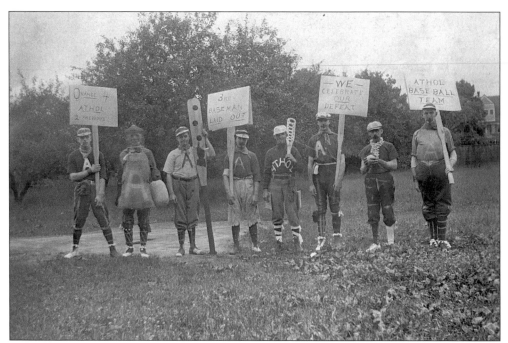

Unfortunately, time has obscured the identities of all but one of this eight-man (?) Athol baseball team, *c.* 1909. The team has apparently been beaten by a team from Orange and is now "celebrating" the defeat. Howard Ford is identified as being fourth from the right, with "Athol" emblazoned on his shirt.

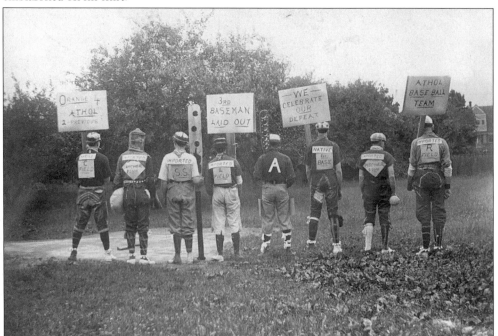

One can only speculate as to the fate of the ninth member of the losing team. Perhaps he was too embarrassed to be in the picture or clever enough to avoid being captured on film by being the photographer. Notice the birdcage being worn by the team catcher, second from the left.

Nine
SOUTH ATHOL

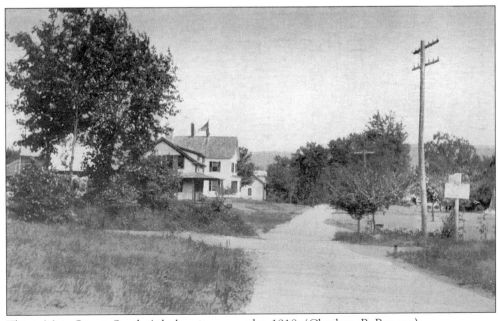

This is Main Street, South Athol, as it appeared *c.* 1918. (Charlena B. Powers.)

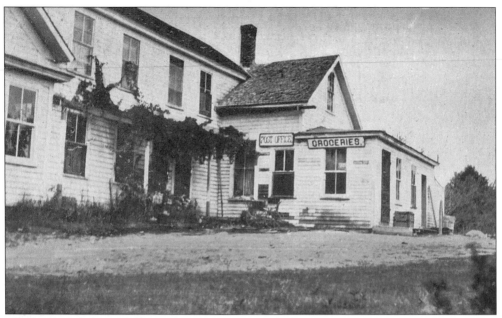

The South Athol Post Office and general store of Charlena B. Powers are shown here in this *c.* 1918 image. Miss Powers was South Athol Postmaster from 1916 to 1940. (Charlena B. Powers.)

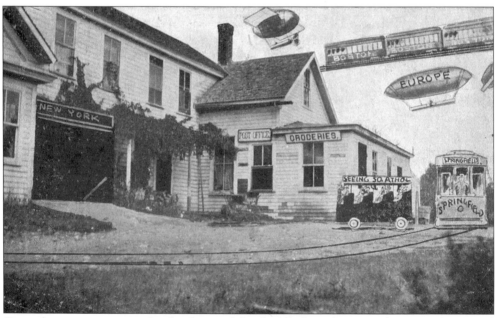

Great things were in store for the future of South Athol, as shown in this *c.* 1918 postcard image. Notice the subway to New York entrance at the left. (Charlena B. Powers.)

The Methodist
Episcopal
Church in
South Athol,
which was
erected in
1836, is seen
here c. 1906.
South Athol
did not
become a part
of Athol until
1837, when
sections of
New Salem
were taken to
form parts of
the towns of
Athol,
Orange, and
Prescott.

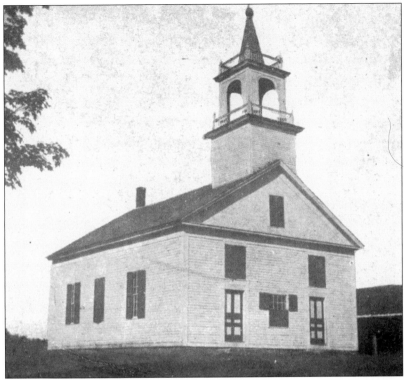

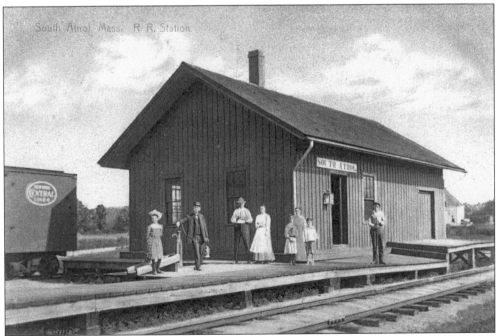

The railroad station at South Athol stood along the tracks of the Athol & Enfield Railroad. The railroad opened for service in the early 1870s and succumbed to the creation of the Quabbin Reservoir in the 1930s. In 1892, passengers rode the 5 miles from Athol to South Athol for 12¢. The station is shown here, c. 1910. (Clapp & Ingalls.)

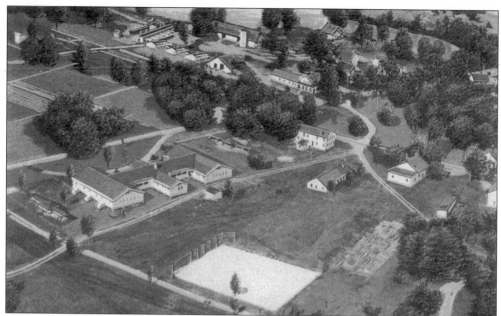

The Morgan Memorial Fresh Air Camps at South Athol were first opened about 1907. Their purpose was to provide a country retreat for the underprivileged and handicapped from Boston —a mission that it fulfills to this day. In addition to the camps, Goodwill Workshops on the site included a rug and blanket factory, a canning factory, a toyshop, and a mineral water bottling plant. (Tichnor.)

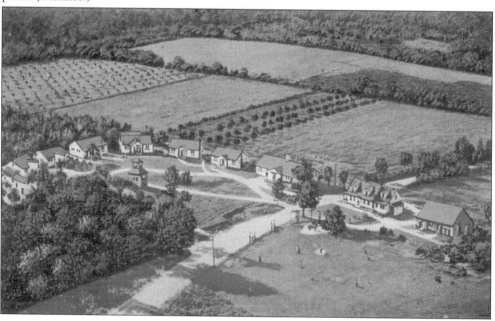

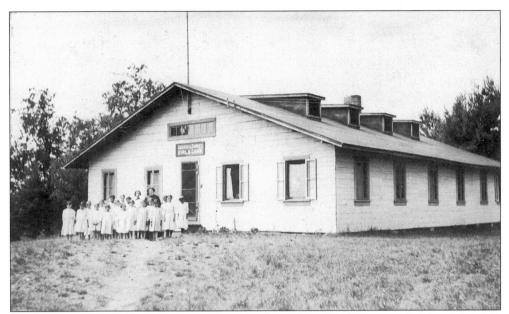

This *c.* 1915 view of the George A. Downey Girls Camp shows but one of the many camps comprising the Morgan Memorial Fresh Air Camps in South Athol.

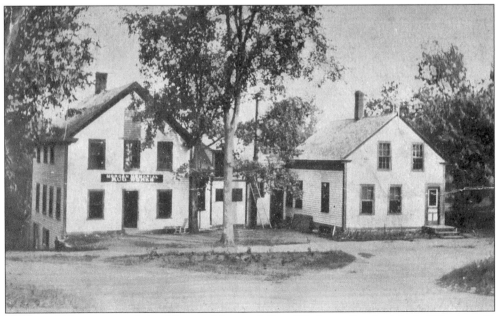

This *c.* 1912 image is of the Morgan Memorial Rug Works at South Athol. (Charlena B. Powers.)

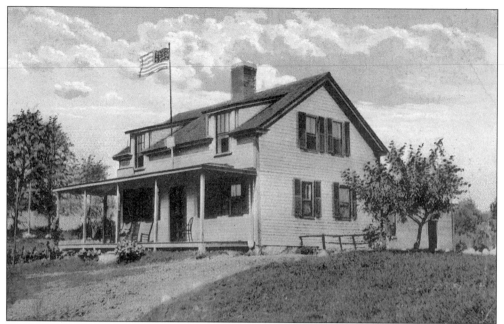

The Helen Steel Fiske Administration Camp at the Morgan Memorial Fresh Air Camps facility in South Athol is shown in this *c.* 1915 view. (Charlena B. Powers.)

Crawford Rest Lodge at the Morgan Memorial Fresh Air Camps facility in South Athol is shown in this photograph.

Ten

ORANGE

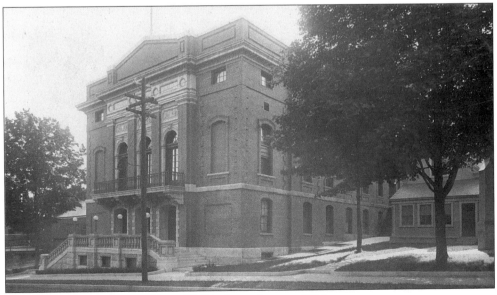

The Orange, Massachusetts Town Hall is shown here, *c.* 1914.

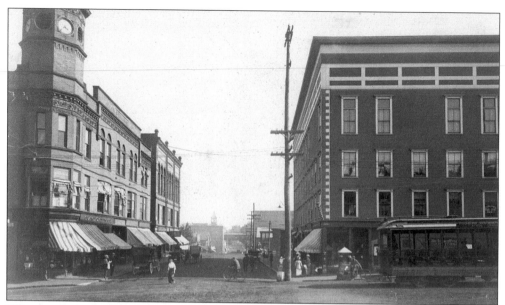

This view from the Square looks south on South Main Street. The Lamb Block is on the right. The Mann Block is on the left with the clock tower, *c.* 1914. (Underwood & Underwood.)

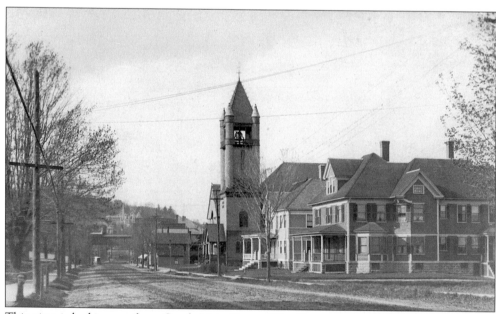

This view is looking north on South Main Street. The Congregational Church, with its large steeple, dominates the scene. The passageway over the street in the distance connected buildings of the New Home Sewing Machine Company. The scene is *c.* 1915. (Eastern Illustrating.)

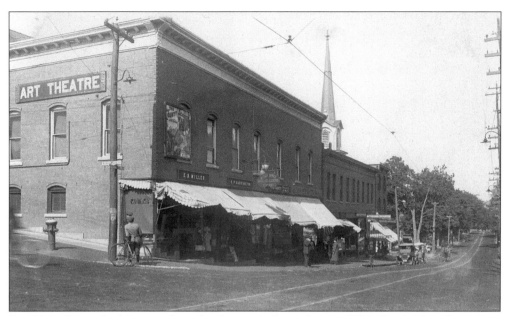

East Main Street, looking east from the Square, is shown here *c*. 1914. North Main Street is to the left where the fire hydrant is pictured. (Underwood & Underwood.)

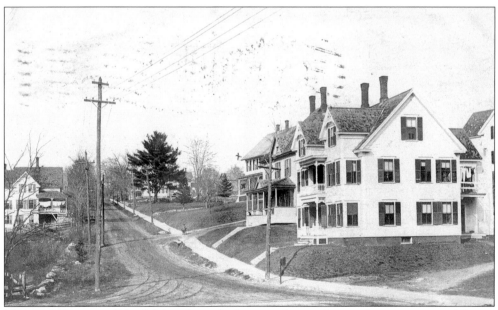

This *c*. 1912 image of North Main Street looking north was taken at the intersection of Dexter Street, which branches to the left.

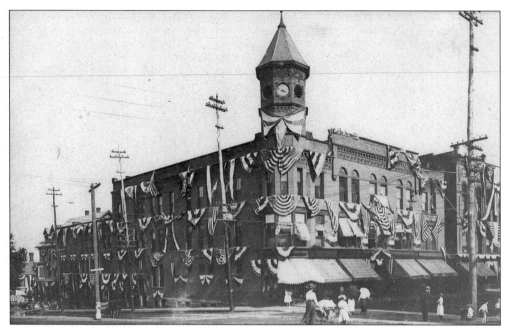

The Mann Block, which stood at the southeast corner of East and South Main Streets, is shown decorated for the 100th Anniversary Celebration of Orange in 1910.

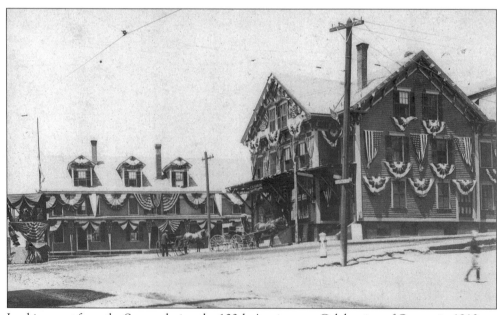

Looking west from the Square during the 100th Anniversary Celebration of Orange in 1910 are the Harlow Block, on the right, and the Putnam House.

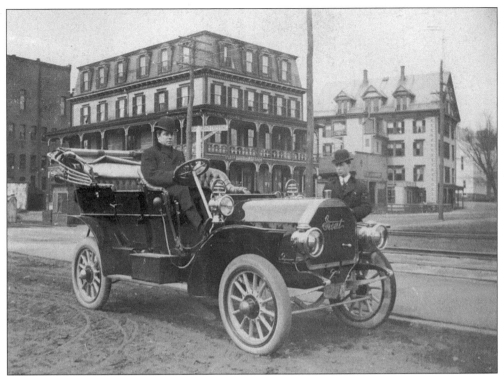

The Grout automobile, which was built in Orange, is shown here prior to the 100th Anniversary Celebration of Orange in 1910. Visible in the background is the American House, which stood on the site of the Orange District Court parking lot.

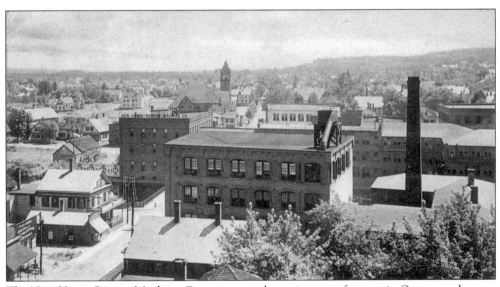

The New Home Sewing Machine Company was the major manufacturer in Orange at the turn of the century. This view looks south from the Square and shows only a small portion of the factory. The steeple in the distance is that of the Congregational Church on South Main Street. The image is c. 1909.

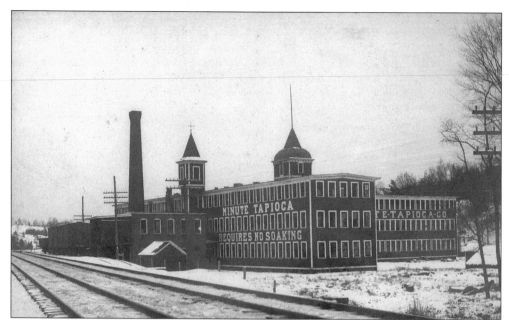

This *c.* 1910 view, looking northwest from the railroad tracks, is of the Minute Tapioca factory. West Main Street passes the building at the far right. This facility is now occupied by Rockwood Industries.

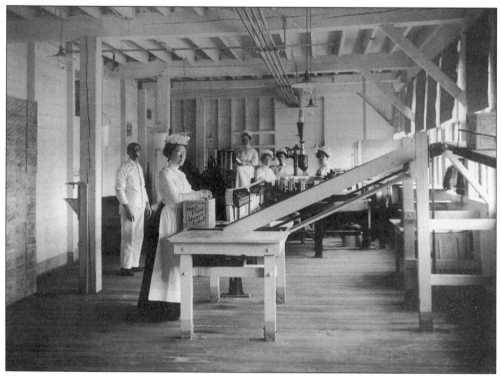

This *c.* 1900 view shows a part of the interior of the Minute Tapioca factory on West Main Street. The Minute Tapioca slogan, "Once Tried Always Used," appears on the wooden box being packed by the lady in the foreground.

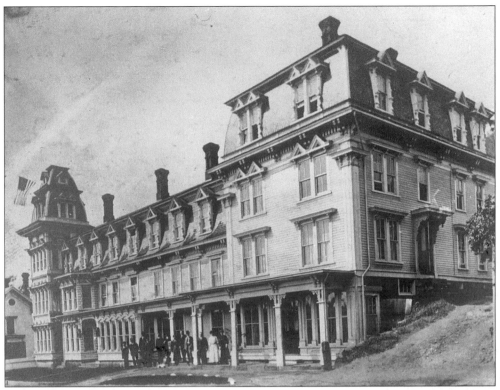

The Mansion House was located just west of the Getty gas station on West Main Street. It is shown here, c. 1905.

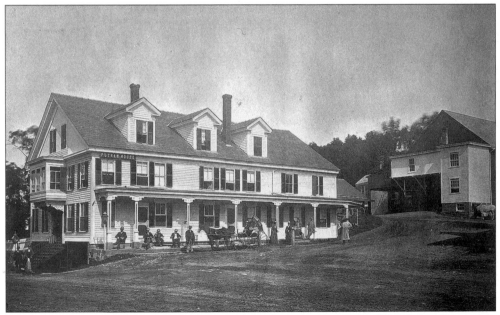

The Putnam House was located on the site of the Getty gas station on West Main Street. Mr. A.P. Putnam was proprietor. An advertisement that appeared in an 1896 Orange Directory billed the facility as being "run under strictly temperance principles." (Lithotype.)

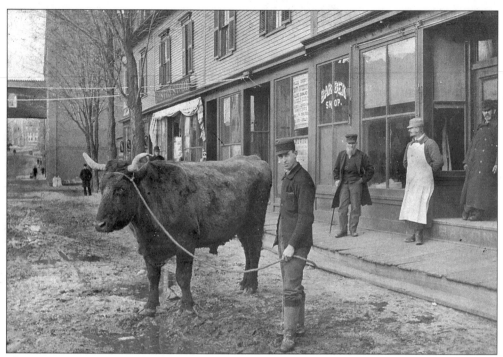

This gentleman is proudly displaying his prized ox in front of the Bingham Block on South Main Street. The Bingham Block stood on the southeast corner of the intersection of South Main and East River Streets. The large building to the left is a part of the New Home Sewing Machine Company, with the passageway over South Main Street visible at the far left. (Harris & Johnson.)

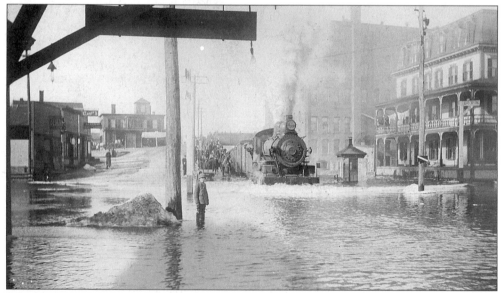

February 14, 1900, saw considerable flooding in the center of Orange. This view looks west from the Orange Railroad Station. The tall brick building now houses the Orange District Court. The American House at the right stood in the court parking lot. The buildings to the left stood in the area now used as the common/Peace Park.

This view is Main Street, North Orange, looking east, *c.* 1910. The Levi Cheney house at the left no longer stands.

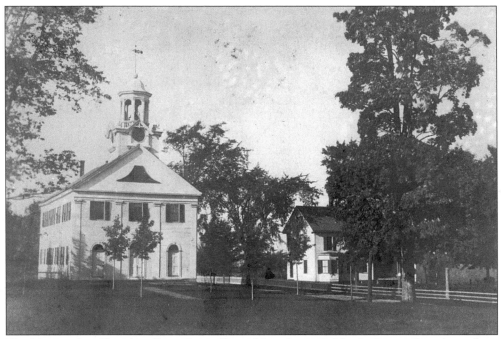

The Universalist Church still stands regally on Main Street in North Orange. It is shown here *c.* 1905.

BIBLIOGRAPHY

Athol Directory 1914–15. New Haven, CT: The Price & Lee Co., 1914.

Athol Directory 1934. New Haven, CT: The Price & Lee Co., 1934.

Athol Illustrated. Gardner, MA: Lithotype Printing Company, nd.

Athol, Orange, Erving, and Templeton Directory 1894. New Haven, CT: The Price & Lee Co., 1894.

Caswell, Lilley B. *Athol, Massachusetts, Past and Present*. Athol, MA: The Athol Transcript Co., 1899.

Howe, Donald W. *Quabbin, The Lost Valley*. Edited by Roger Nye Lincoln. Worcester, MA: The Davis Press, Inc., 1951.

Lord, William G. *History of Athol, Massachusetts*. Somerville, MA: Somerville Printing Company, 1953.

Millers River District Directory 1885. New Haven, CT: The Price & Lee Co., 1885.

"Review of Athol's Industries and Property." *Worcester West Chronicle*. Supplement, January 1, 1891.

Ryan, Dorothy B. *Picture Postcards in the United States 1893–1918*. New York, NY: Clarkson N. Potter, Inc., 1982.

"Supplement-150th Anniversary Edition of Athol's Incorporation." *The Athol and Worcester West Chronicle*, June 20, 1912.

The Anthony Business Directory and Reference Book of Athol, Orange, and others 1892–1893. Meriden, CT: The Anthony Publishing Company, 1891.

The Orange Directory. Orange, MA: The Orange Journal Print, 1896.